THE ENDINGS

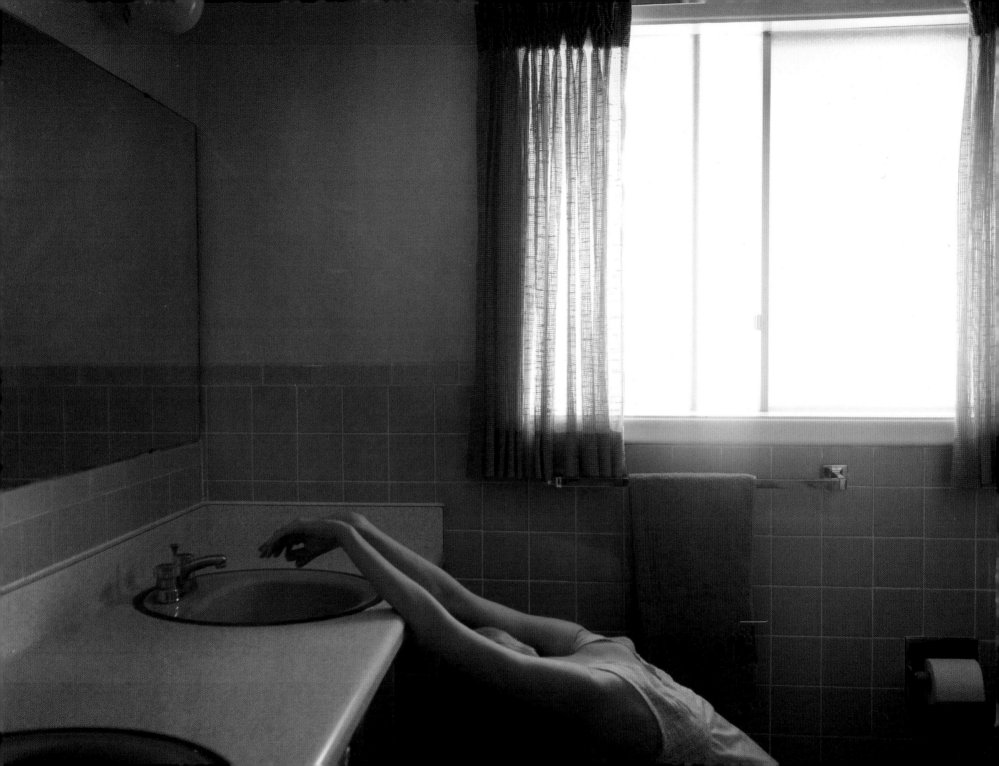

THE ENDINGS

PHOTOGRAPHIC STORIES OF LOVE, LOSS, HEARTBREAK, AND BEGINNING AGAIN

BY CAITLIN CRONENBERG AND JESSICA ENNIS

FOREWORD BY MARY HARRON

CHRONICLE BOOKS

SAN FRANCISCO

Library of Congress Cataloging-in-Publication Data available.

ISBN: 978-1-4521-5568-5

Manufactured in Hong Kong.

Design by Sara Schneider

10 9 8 7 6 5 4 3 2

Chronicle books and gifts are available at special quantity discounts to corpo-
rations, professional associations, literacy programs, and other organizations. For
details and discount information, please contact our premiums department at
corporatesales@chroniclebooks.com or at 1-800-759-0190.

Chronicle Books LLC
680 Second Street
San Francisco, California 94107

www.chroniclebooks.com

TO WOMEN WITH WILD HEARTS
AND A FLAIR FOR THE DRAMATIC

CONTENTS

FOREWORD
BY MARY HARRON

In the first image of *He Said I Was Embarrassing at Parties*, we see Eleanor Tomlinson hunched with her bags at a grim London bus shelter, still in her sparkly party dress. As she drifts home through a quiet suburban street, the camera catches her in close-up, framed against the dawn sky. Her expression is stricken, but perhaps a touch defiant. Maybe she is looking at us; maybe she's not. Maybe she just wants us to go away.

There is something so raw and exposed about the aftermath of a breakup: it really isn't a moment where you want to let anyone in. So it is no surprise that in each of the scenarios of losing or leaving love depicted here the women are almost always alone. In solitude they can let it all out. And it also shows why they look stunned, even paralyzed, by what is happening.

It can't be easy for actors to enter such fraught emotional territory without the guidance of a script, but I understand why they agreed. Caitlin is very persuasive. When I first met her, it was for a photo shoot, and I explained that I hate to be photographed. "Me too," she said. "I'm very shy." Caitlin told me that she began as an on-set photographer, where her shyness turned out to be an asset. On-set photographers are much abused. They are made to stand on the sidelines, only allowed to take shots at certain moments, and compelled to be absolutely quiet and unobtrusive while the chaos of the film shoot swirls around them. It turned out to be a fine training. Caitlin developed a soothing, quiet presence that allowed her to melt into the background and capture moments as the drama played out.

There is a parallel here with documentary, of catching life as it happens, and some of the sequences that Caitlin and her co-director Jessica Ennis have created have the feel of cinema verité. Juno Temple's shoot, which captures a couple of days in the life of a girl on a druggy lost weekend, seems at first sight to have the casualness of life as it happens, but with a closer look you see an intensity in these images that is not random. Unusually for these stories there are other people in this one, but the young men and women are asleep, turned away, obscured. They are not part of the main event, which is Juno Temple's face, either looking into a mirror, seeming lost and sad, or packing up, weary but resilient.

If some of these stories seem so close to documentary, others are very theatrical and incorporate elaborate stage settings that dramatize the subjects' grief. Some are like a sacred rite: In her sequence, one of the earliest to be shot, Sarah Gadon sets fire to a "boyfriend box" of mementos with a cold, burning intensity, as if she can't quite believe what she has done. (The fact that it was Jessica's own boyfriend box must have made it a double catharsis.) And then there is the element of a fashion shoot. These women have really dressed up for their rituals, their burning and smashing and hair-tearing and quiet reflections.

Caitlin and Jessica think of these stories as stills from a film that was never made. Each shoot was a collaboration between just the two of them and the performer on set—and apart from the occasional use of music as inspiration, the performances were mostly conducted in silence. Thousands of photos were taken to get just a few final frames.

An enormous amount of thought and preparation went into getting those few frames for each story: the casting, the development of the narrative, the location hunting, the gathering of wardrobe and props. Caitlin and Jessica created extensive backstories for each character. Sometimes the actors wanted to be involved with developing the story, sometimes not. The goal is always, as Jessica says, to "create a world that feels true and authentic to each character." Jessica not only sought out props that would look good on camera for these shoots, but she also looked for objects that would never be seen. There were items hidden in the drawers, handbags, suitcases, boyfriend boxes, and closets that belonged to the character. With all these elements in place, the actor's improvisation could begin.

In the act of viewing these images, these carefully thought-out details all come into play. Without dialogue or continuous action, you need to zoom in on the details of each photograph to try to discover for yourself the story behind each sequence. Take what seems to be one of the simplest images: Gemma Jones sitting by herself outside an English country cottage. Her pose is still, domestic, an older woman on a bench in a lovely garden, a cup of tea in her hand. But her face looks utterly lost. Is she in mourning? Look closely: Why she is wearing a bedraggled little fur jacket? And underneath, is that an evening gown? I try to make out the object beside her. I zoom in closer. At first it looks like a white purse. Or is it an old-fashioned radio?

I asked what the white object is, and what it means, and Jessica explained:

> The box next to Gemma's character is a 1960s radio. The story is about a woman with dementia. Every day she sits and waits for a man that left her 50 years ago to return. The circumstance surrounding the ending itself is left open-ended, but our thinking was that perhaps he had left during an argument and never returned. Despite now having a husband and a family of her own, she now waits for this man to return—as though not much time has passed. I'd say the radio is simply a symbol of the time when he left. She's re-created her past and made it her current reality.

Do you get all that from the images? I doubt it. But what does it matter? The mystery is what draws us in. In one of the most eerie and beautiful images in this book, Ophelia Lovibond, wearing a pair of wings, is crouched in a concrete tunnel, silhouetted against harsh electric light. You have a feeling that the night will not end well for this fallen angel, not least because this is the same tunnel that was used in the filming of *A Clockwork Orange*. I can't know why she ended up there or what will happen to her, but I have my own ideas. And so should you.

INTRODUCTION
BY CAITLIN CRONENBERG AND JESSICA ENNIS

This is a book about endings—the experience of losing or leaving love. It affects us profoundly. Almost everyone has felt some version of a loss of love, and the emotions that accompany it. When we are at our most vulnerable, our emotions are laid bare. We act on impulse and are uninhibited by logic and reason.

These photographs aim to capture the moments in which we are no longer in control and our actions are dictated by how we feel, not how we think. Who does a person become when she is so overwhelmed by her feelings? These images tell stories of sadness, loneliness, anger, relief, rebirth, freedom, and happiness. They are explorations into raw emotions, looking at female characters at a crossroads, and how they move forward (or don't) after heartbreak. Each story exposes the most personal of moments: the one when you know it's over.

The stories are about relationship endings, but they are also about beginnings. They capture the journey of moving on. Starting again. These are the stories we set out to tell. And the photographs are as much about what you don't see as they are about what you do see.

We originated the concept and backstory for each photographic narrative together, and then collaborated with each actor to further develop her character and intentions—who she was, what happened in her life, how the relationship ended, and when. Next, we designed an environment for her with as much detail as we could. The goal was always to bring to life a real, lived-in space, rather than simply a set for the actor to stand in front of.

Before each shoot, we told our actors to live in the space and not think about stopping to pose for the camera. Giving our subjects the freedom to "just be" and not feel like they needed to stop for the shot was liberating both for them and for the photography. It required an acceptance that not every photo would be perfect or sharp. The goal was to capture the moments in between: the real moments that convey true emotion. The result is photographs that have a cinematic look and evoke the feeling that something is ending before our eyes.

The first shoot set the tone and process for the rest of the book. When Christine Horne entered the room we designed, fully inhabiting

the character we created, this project became something different from other photo shoots we had done. We stepped back and allowed Christine to live the story while we were shooting and watching the action. The rest of the crew instinctively hid just out of her eyeline in another part of the room. We all fell silent and watched as this beautiful, sad soul packed up her belongings into suitcases, tried on old clothes in the process, danced on her bed, relived happy memories, and paused thinking of somber ones. She went to the record player and put a song on: "Bridge Over Troubled Water" by Simon & Garfunkel. As the crackling record struggled to push out the first notes, she began to cry. We looked at each other. We were crying too. She had transformed into the character so seamlessly that we had forgotten she was acting.

There is an intimacy and a trust that we developed with our subjects. We watched them be vulnerable and they allowed us to capture it. It was a very powerful process. We directed when we felt we needed to. Often we put on a curated collection of songs and let the music set the mood for the shoot, so we did not have to say a word and risk taking them out of the moment.

The stories that we created and shared with each actor before shooting were fiction, but were largely based on our own stories or the stories of our friends: women trapped in memories of long ago, women who take revenge and ultimately feel empowered, women who are broken, and women who are rebuilding. While each backstory was detailed and specific, we know that each viewer will have their own way of interpreting each series of photographs. We have included written summaries of each story in the back of the book, but have kept them separate from the photos to give you a chance to make your own interpretations first.

One of the stories tells the tale of a young woman who is in such a downward spiral after the end of her relationship that she seeks com-

fort in the beds of many men and women. We spent seventeen hours traveling as a crew around Brooklyn, changing hair, makeup, and wardrobe for each new scenario to make it feel like a different day and time. Over the course of our day, we lived this woman's story together, and drew upon our personal experiences to make it feel real. Our crew all made cameos that day, taking our relationship with this project one step further. We are the book and the book is us.

So many women we encountered volunteered material from their own experience. One of our collaborators allowed us to use the story of how she moved to New York City after finding out her husband was gay, which you will see depicted by Danielle Brooks. Mary Harron, the author of the foreword to this book, told us a story she had heard about a woman who cut up all of her lover's clothes into tiny little squares when they broke up. We were immediately inspired. The last story in this book is based on Mary's story.

Bringing these stories to life with inspiring, talented women whom we have loved and respected for years has been a deeply gratifying experience. Our work on this project has taken each of us through a pregnancy, through our own personal joys and heartbreaks, and has presented certain unexpected challenges, like locating a pig's heart in the middle of the night (as you'll see). It has been a labor of love getting this project to the finish line, and the result is something we could not have imagined when we set out to make this book. We know that each of you will view this book with a unique perspective. Some of the stories and themes may resonate deeply with your own experiences, while others may serve as pure entertainment. However these stories and photographs find you, we hope sincerely that they will stay with you, as they have with us.

11:11

FEATURING SARAH GADON

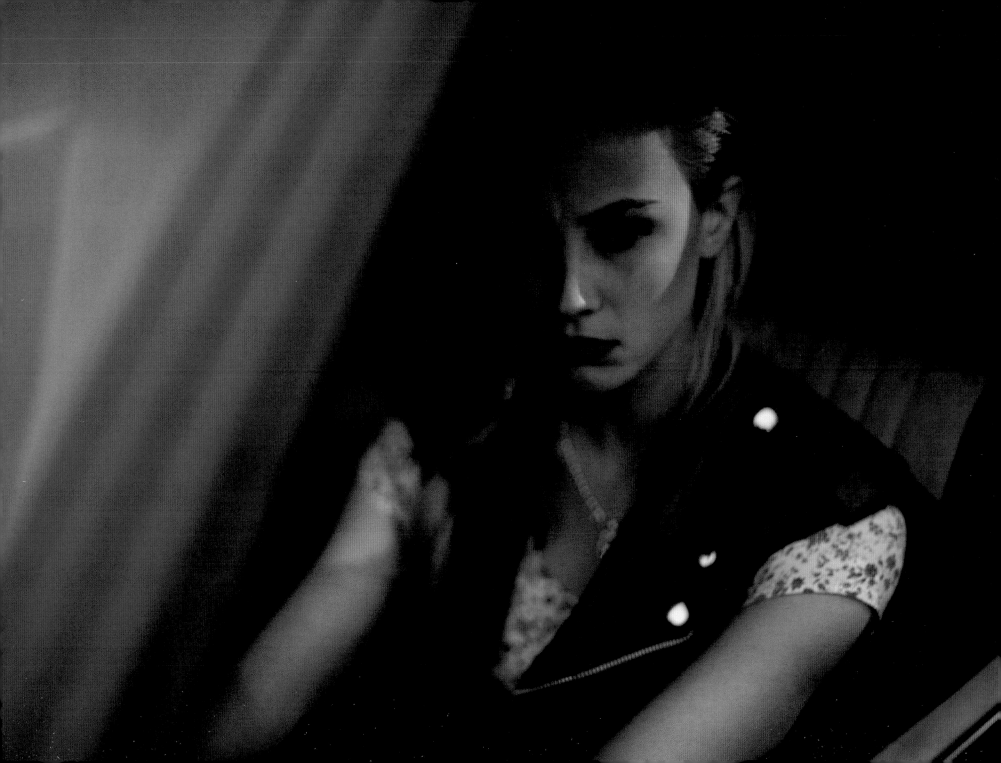

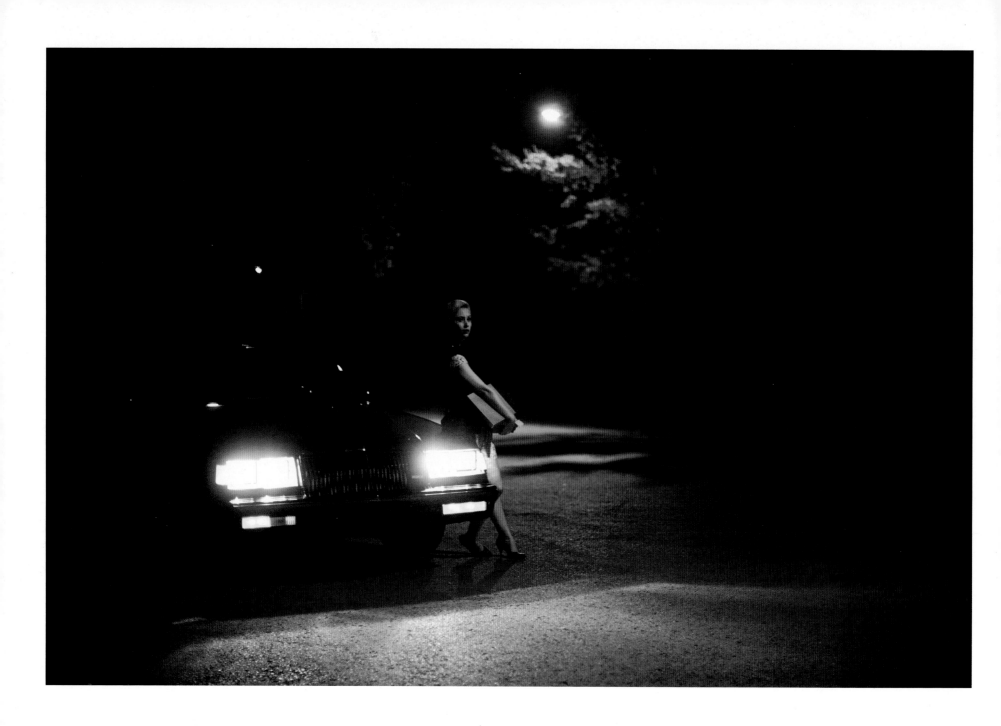

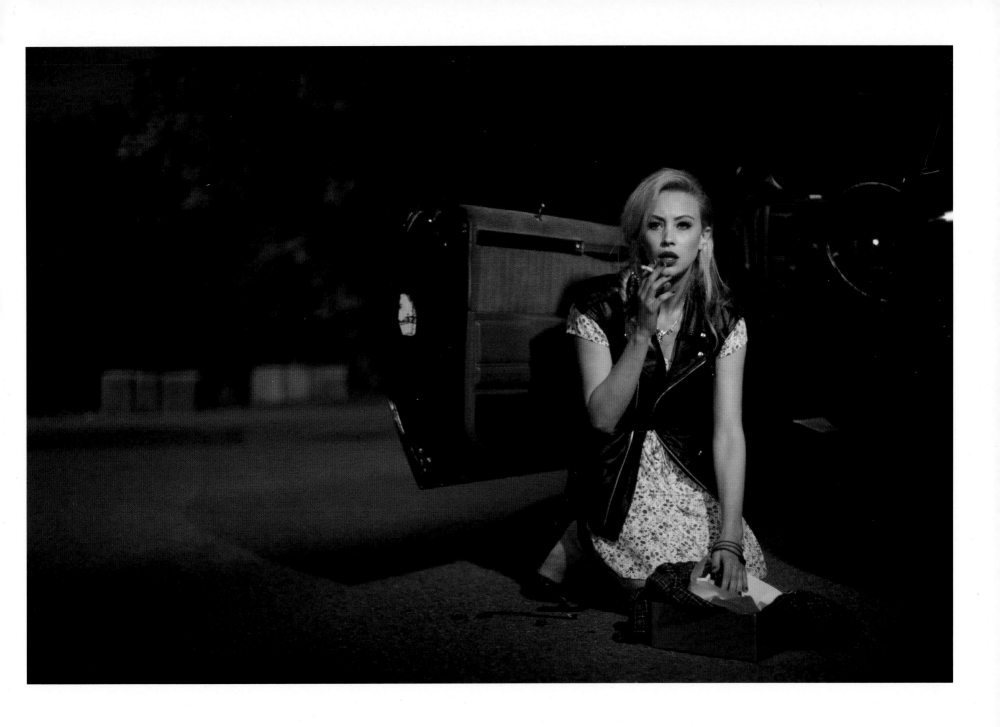

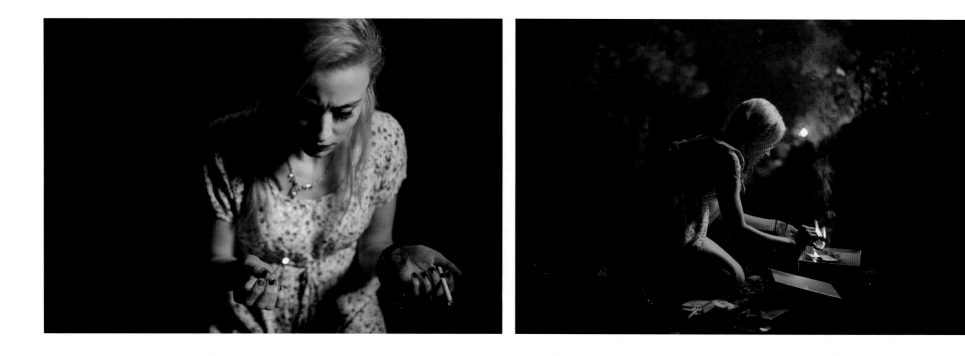

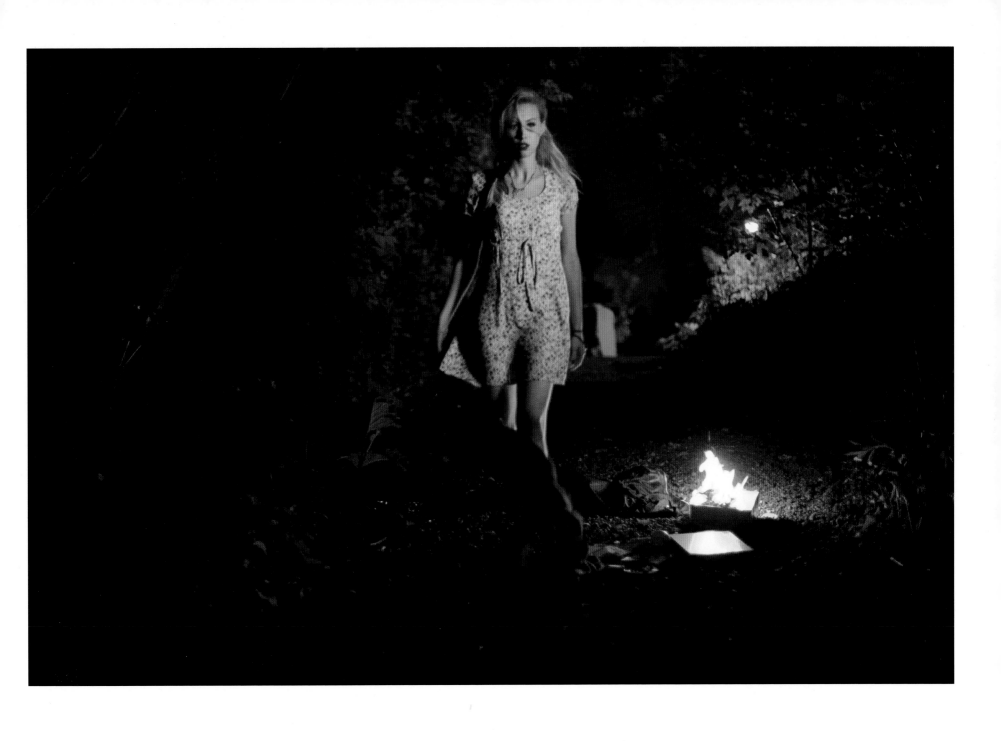

TO ALL THE MEN WHO LEFT ME HERE

FEATURING NOOMI RAPACE

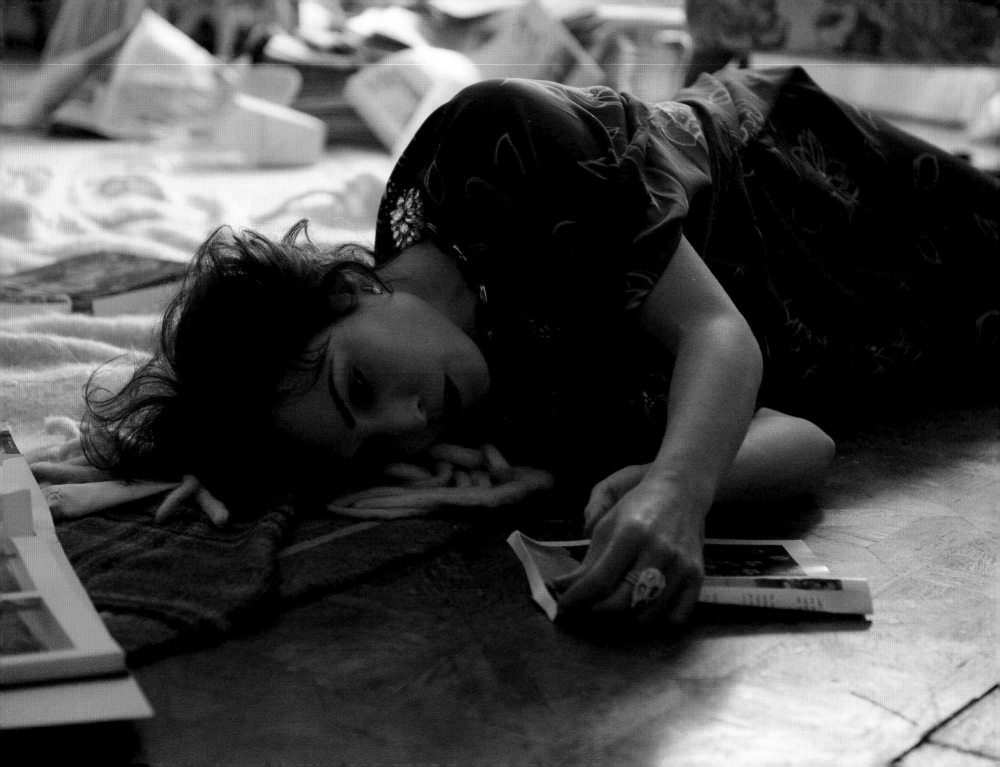

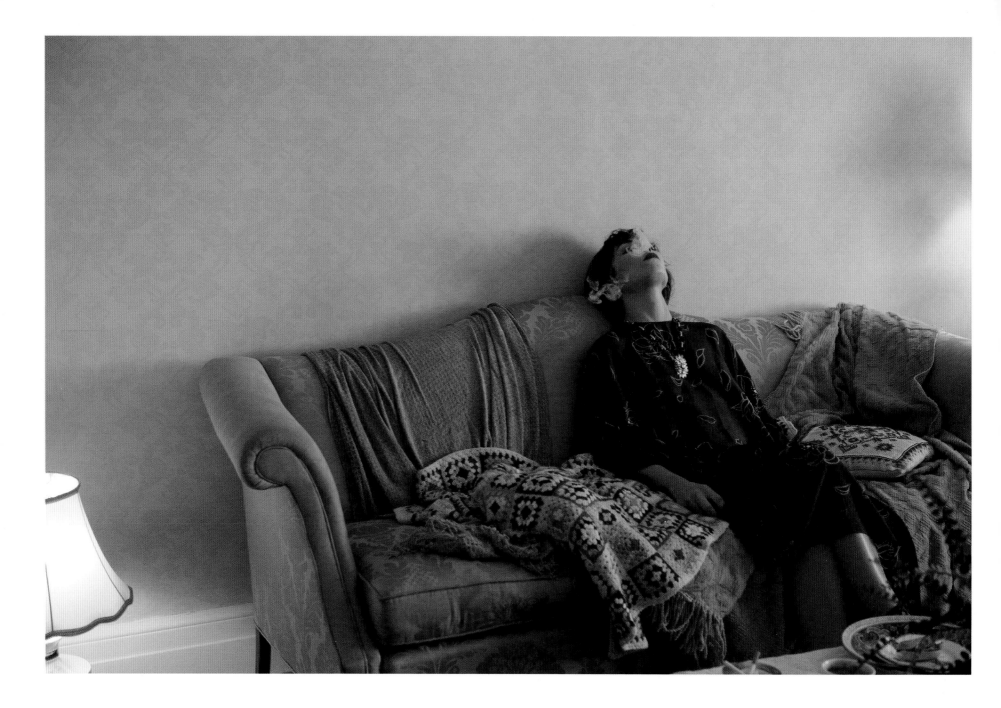

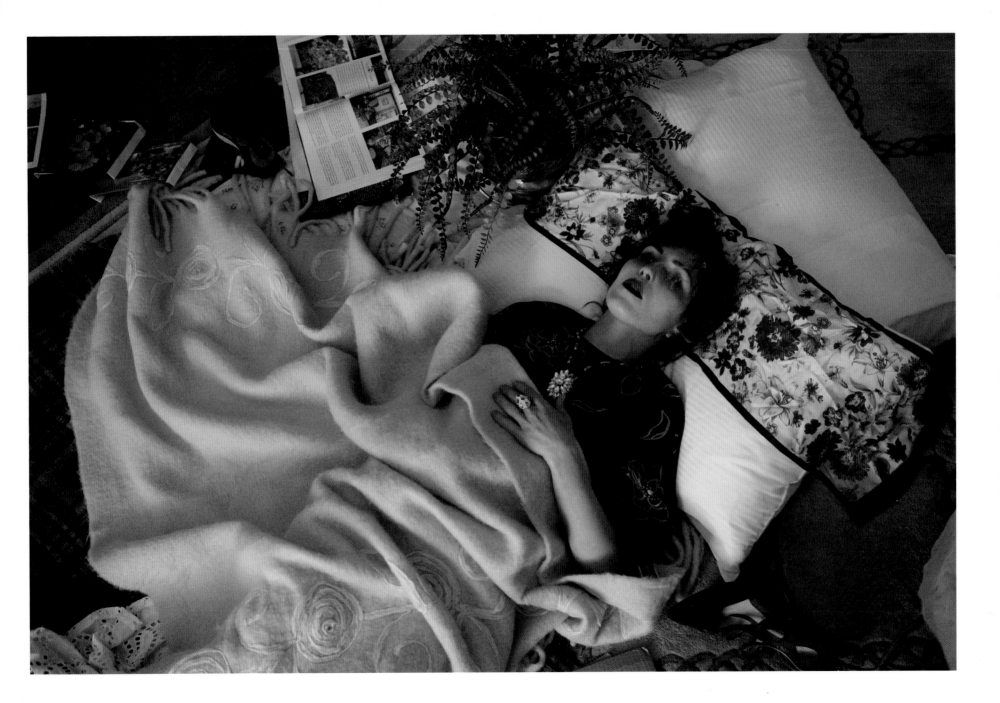

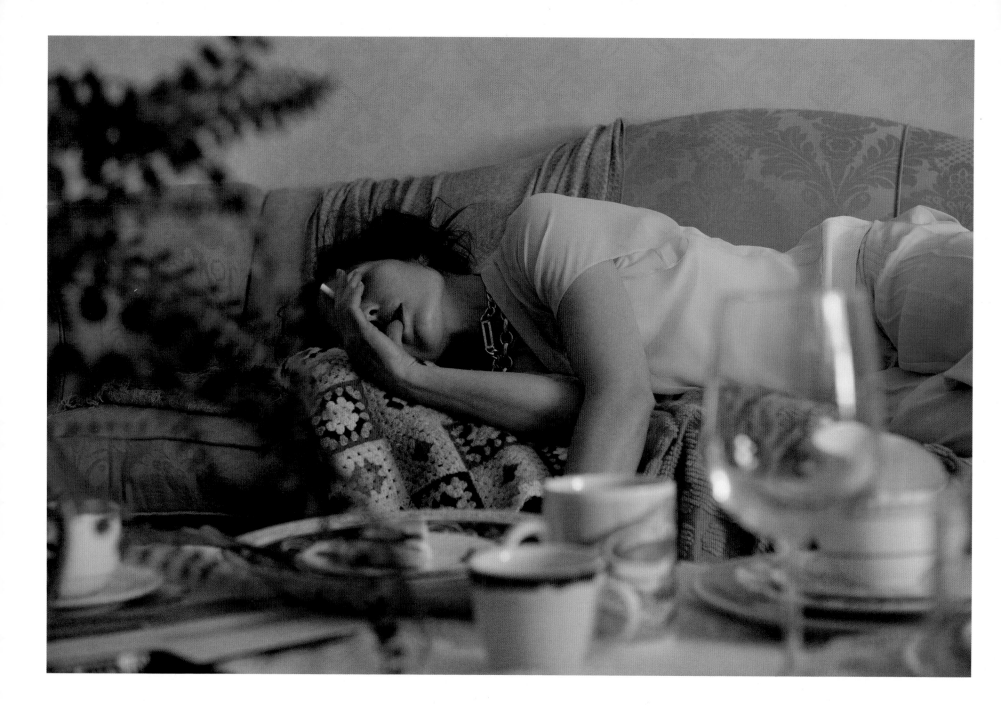

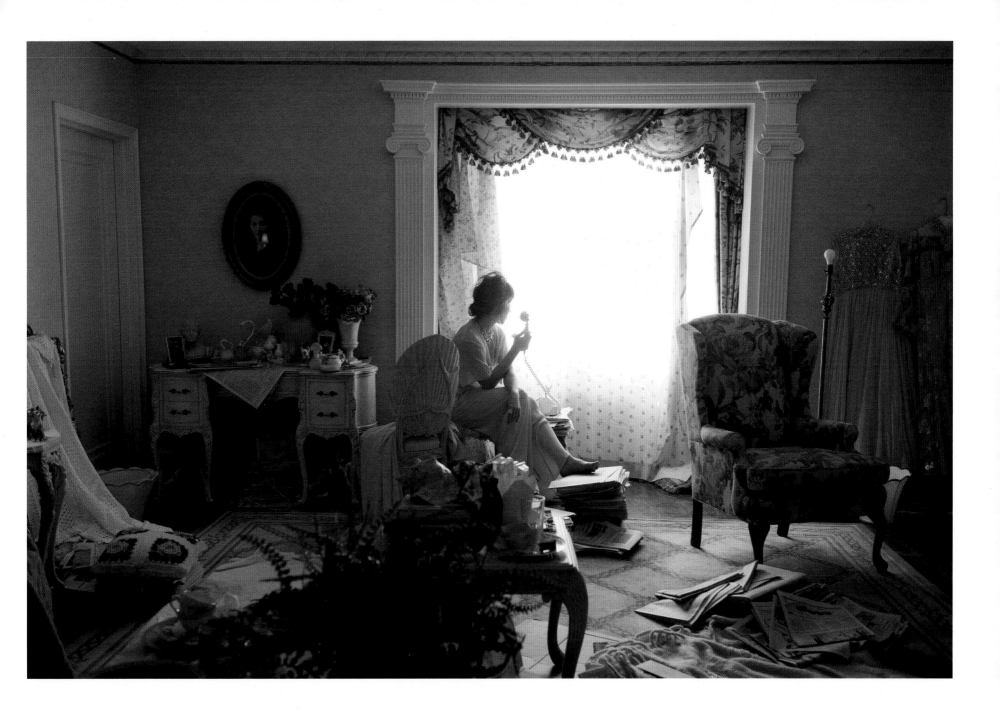

IN THIS HOUSE
FEATURING MENA SUVARI

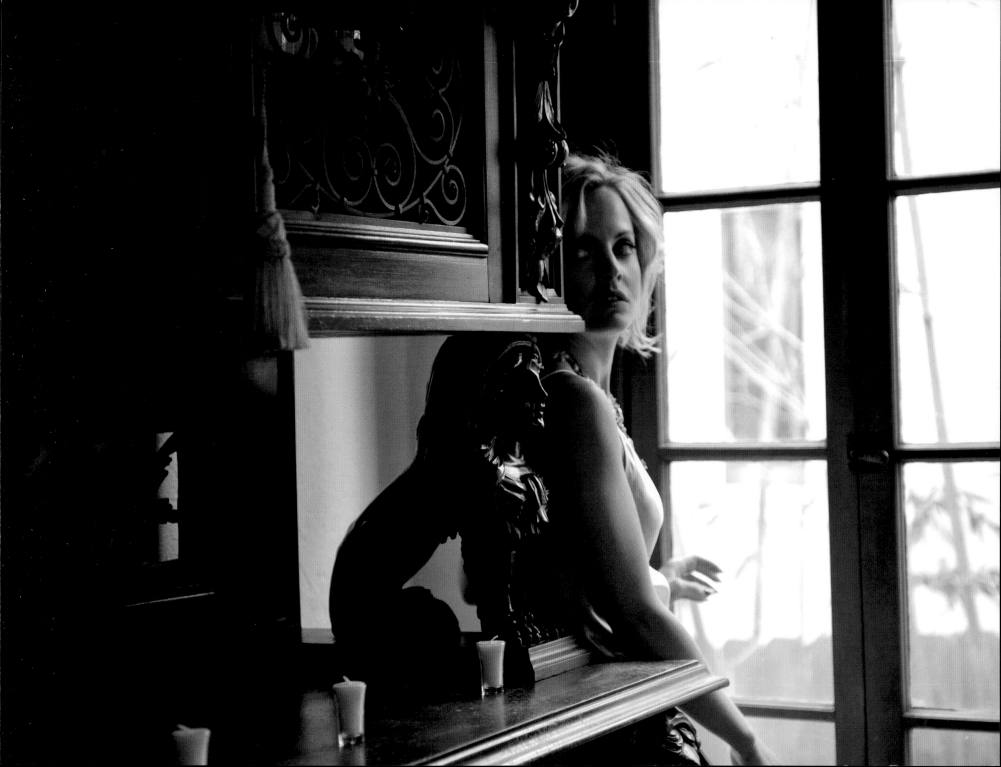

HE'S DUE HOME BY SUPPER

FEATURING GEMMA JONES

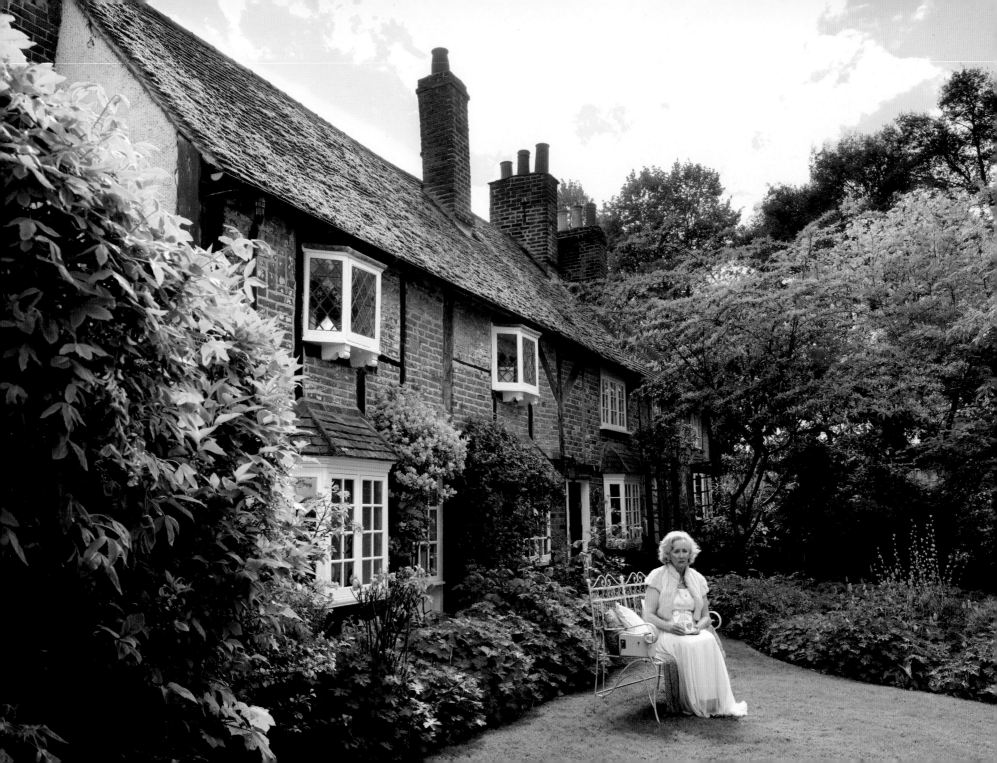

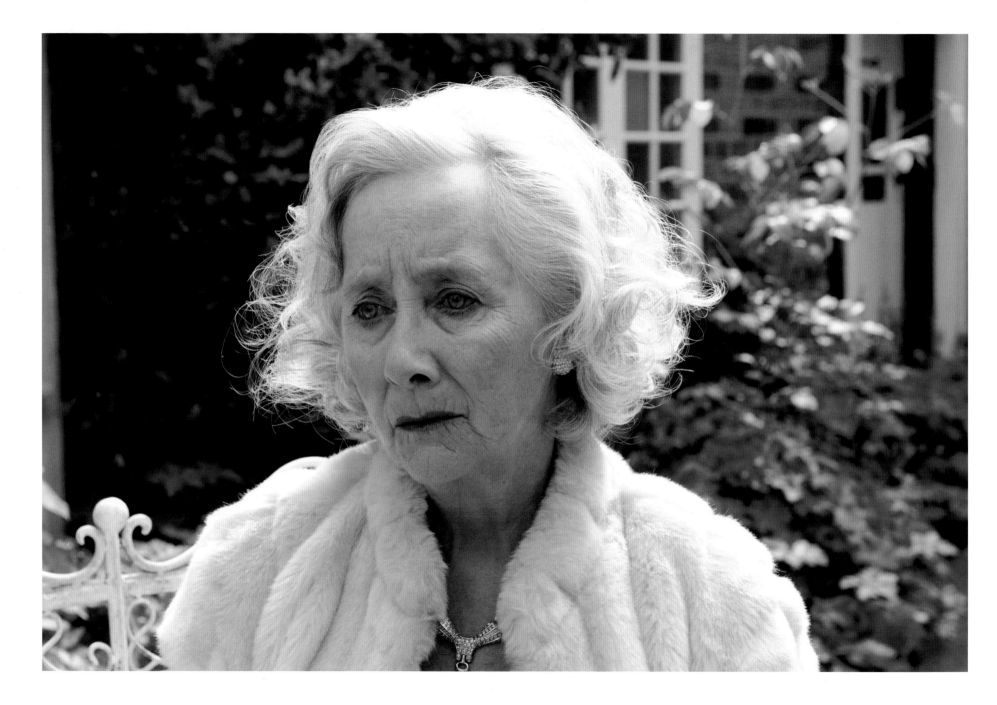

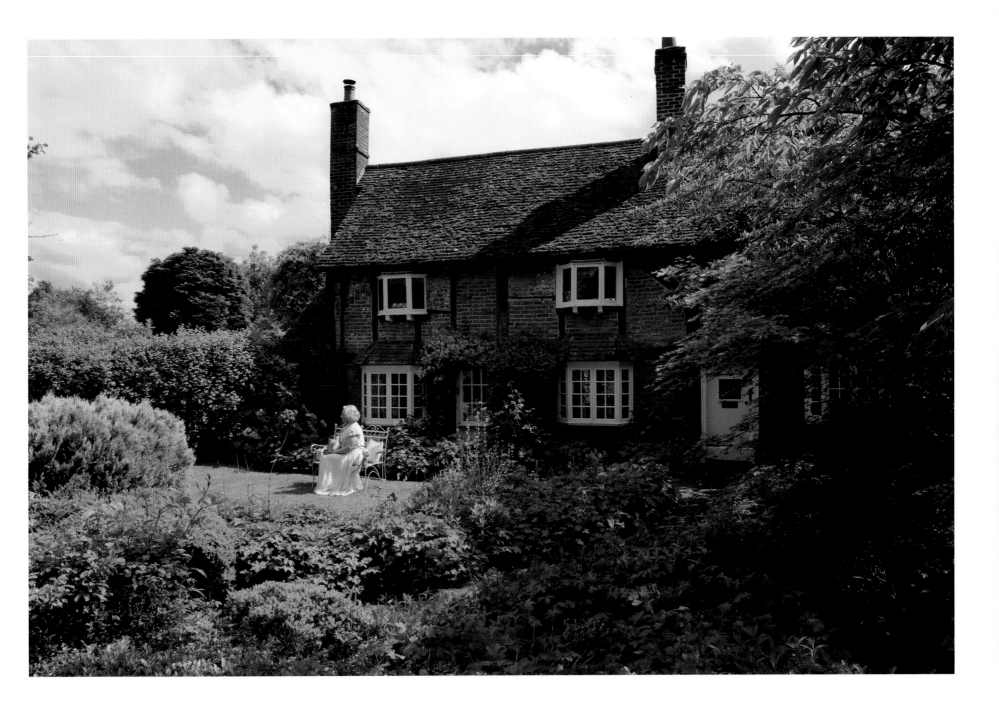

THIS IS WHAT IT IS

FEATURING JULIANNE MOORE

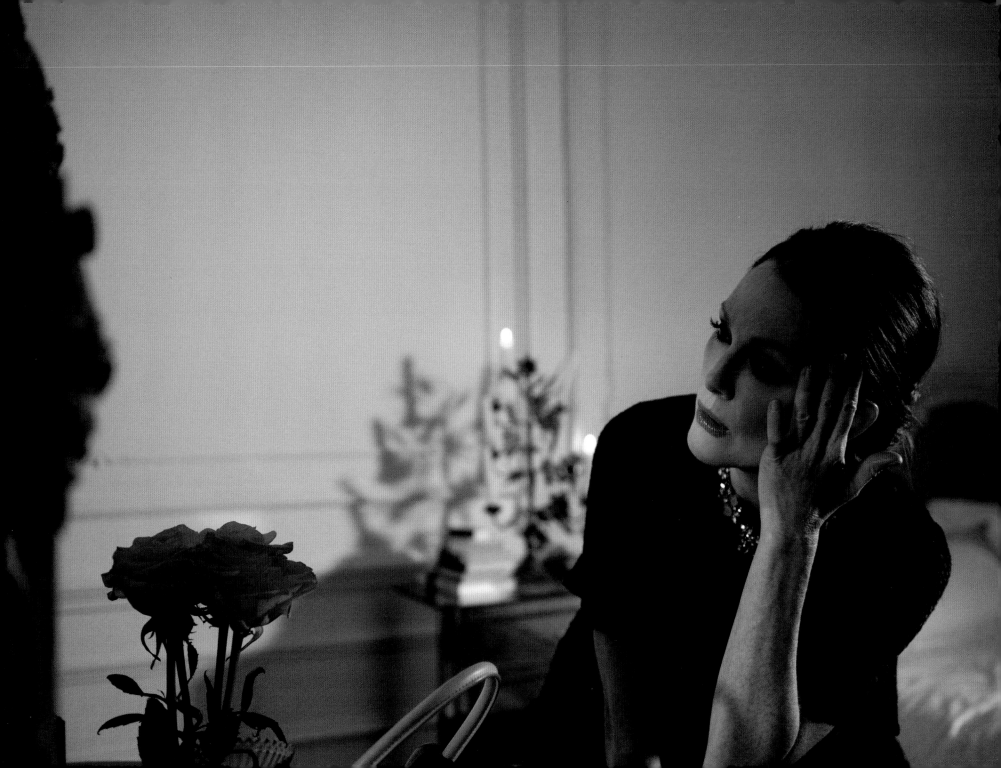

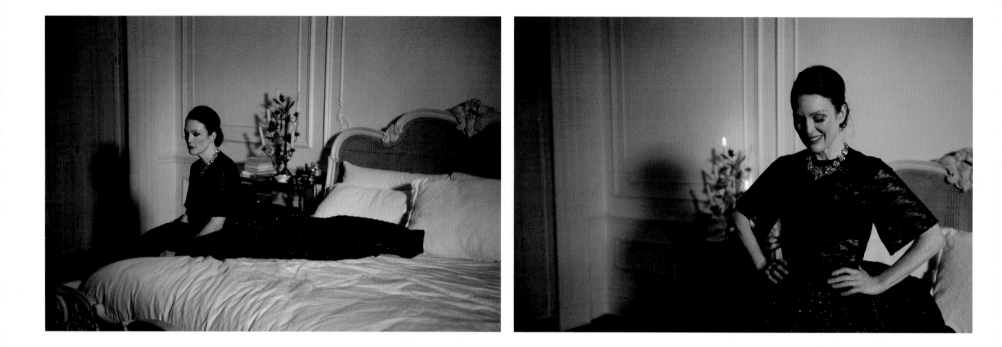

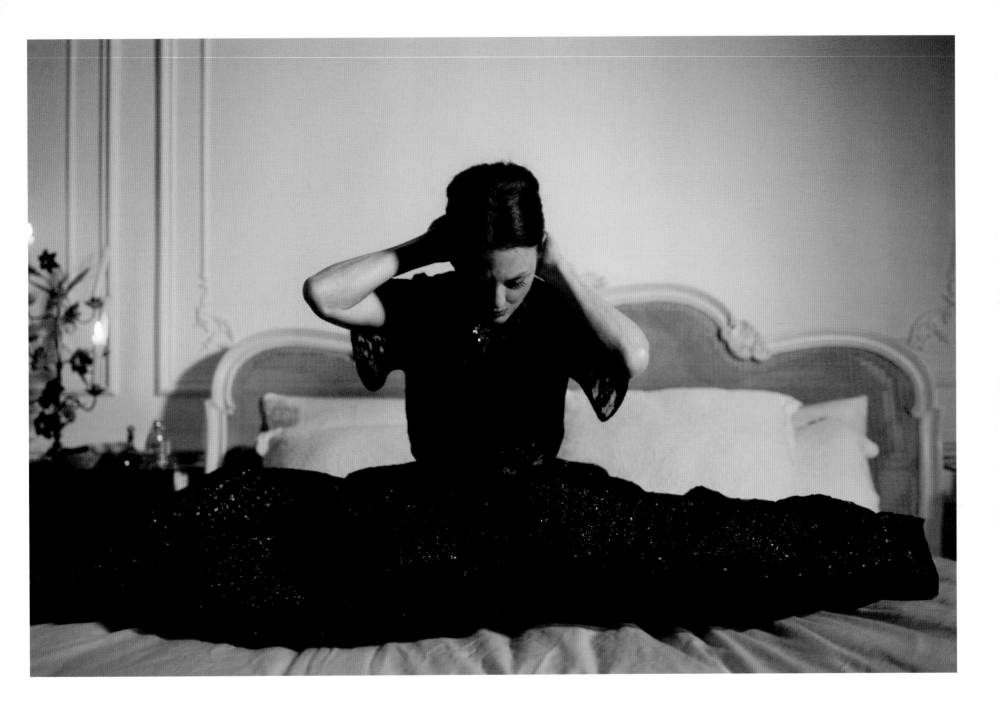

HE SAID I WAS EMBARRASSING AT PARTIES

FEATURING
ELEANOR TOMLINSON

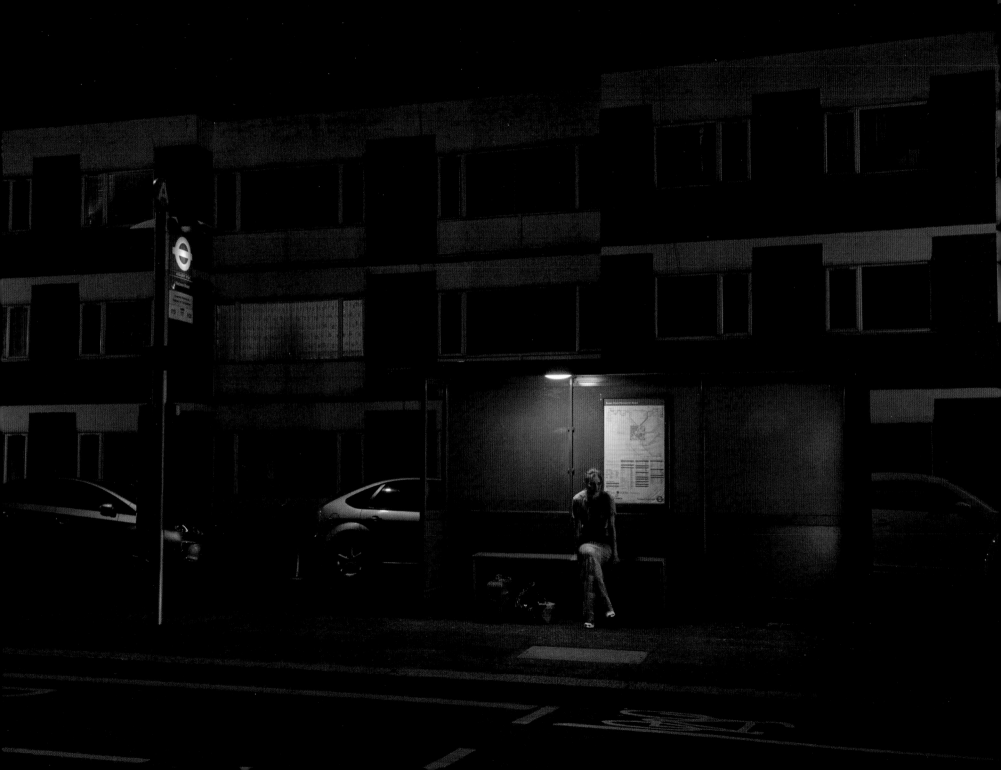

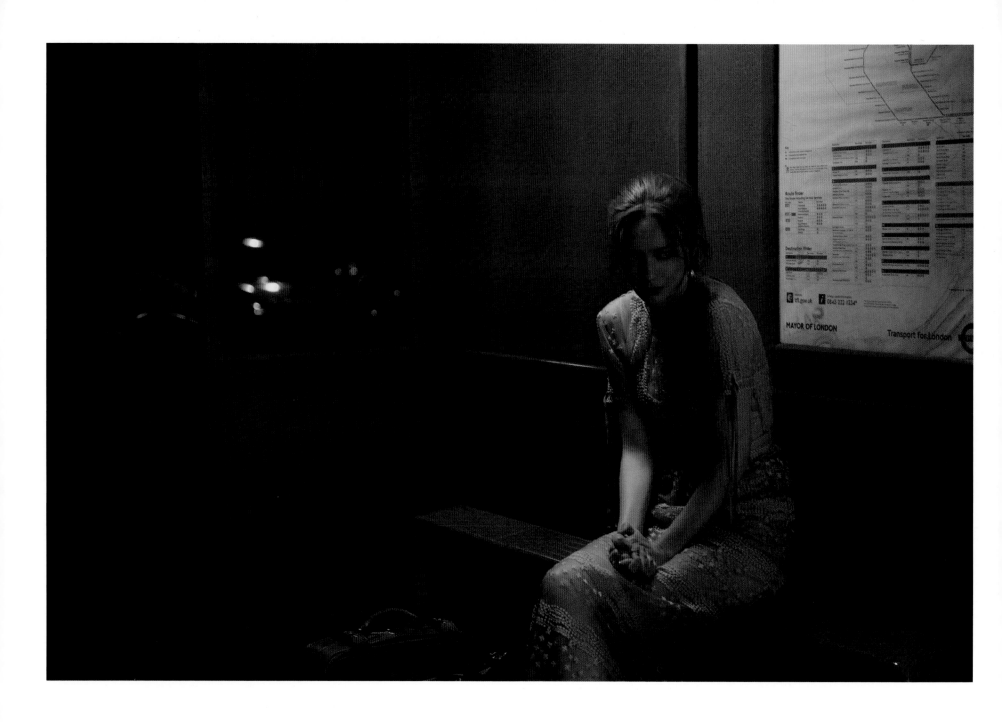

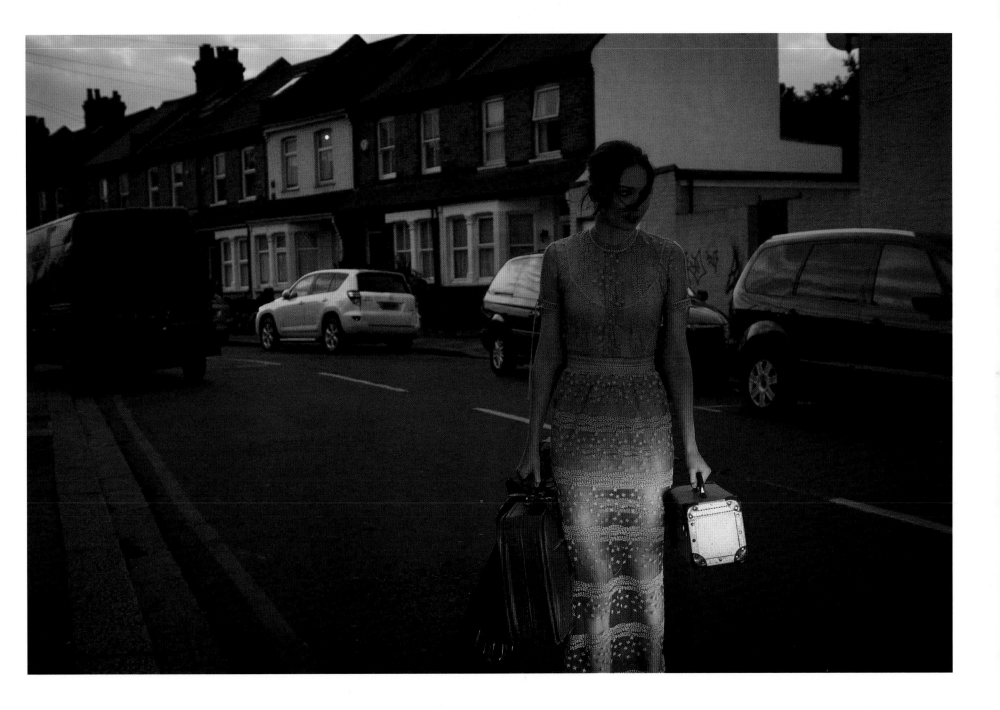

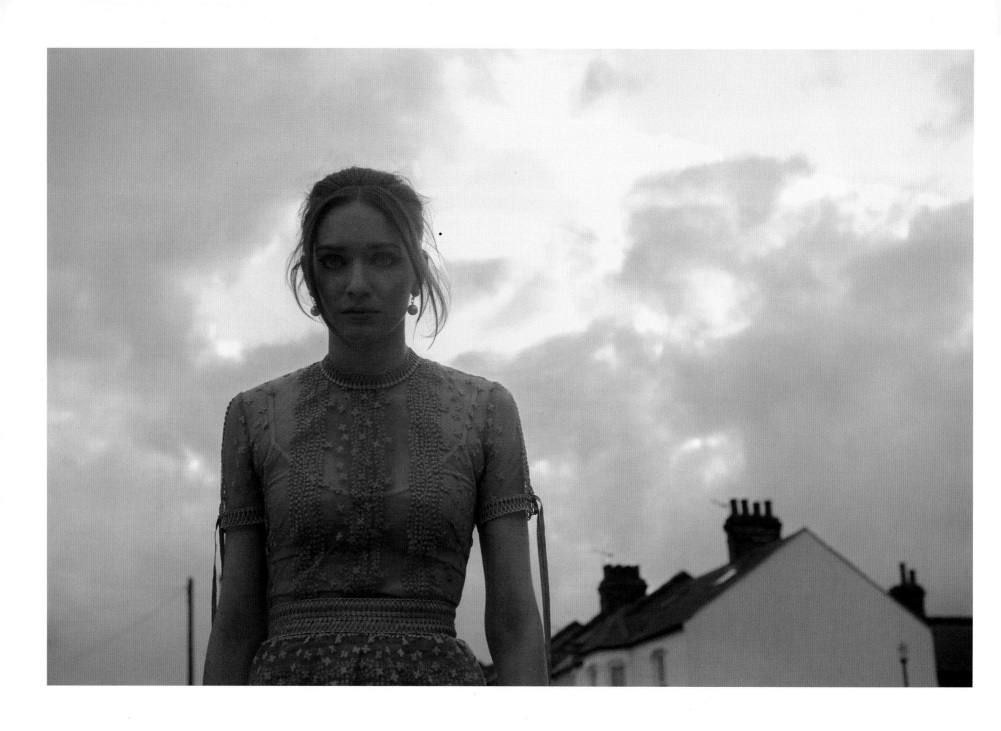

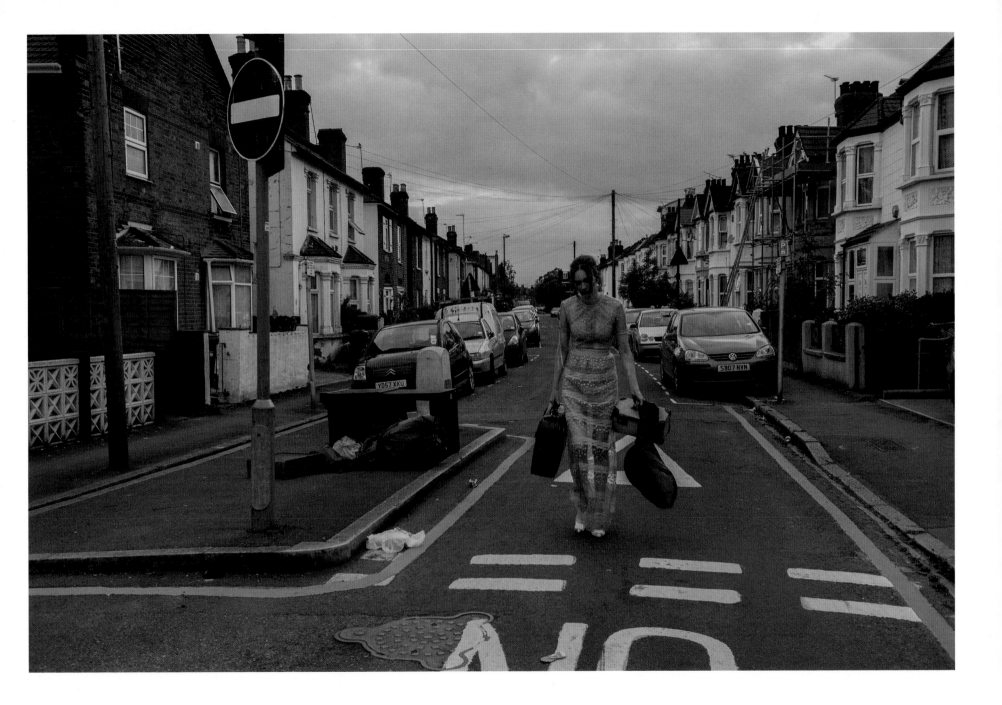

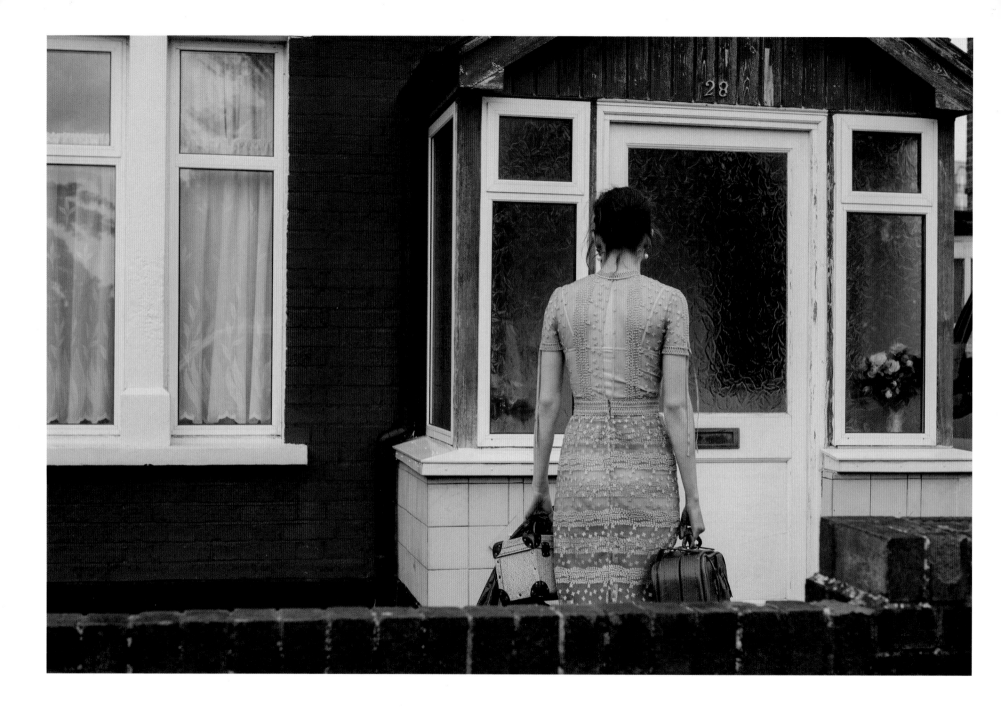

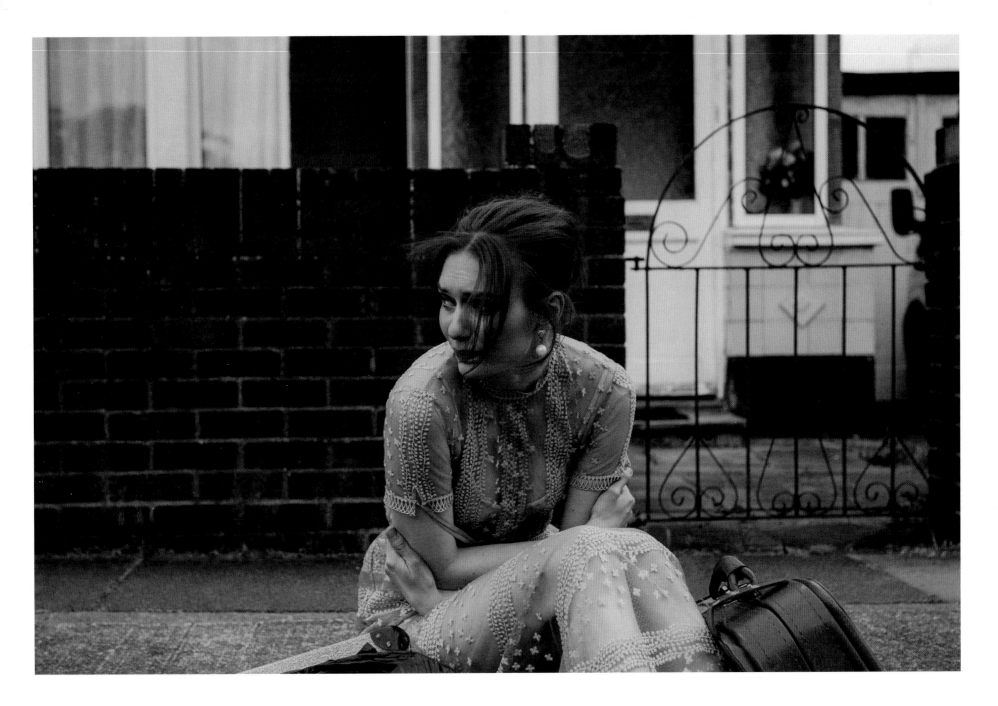

WHAT DAY IS IT?
IT'S TODAY
FEATURING AMANDA BRUGEL

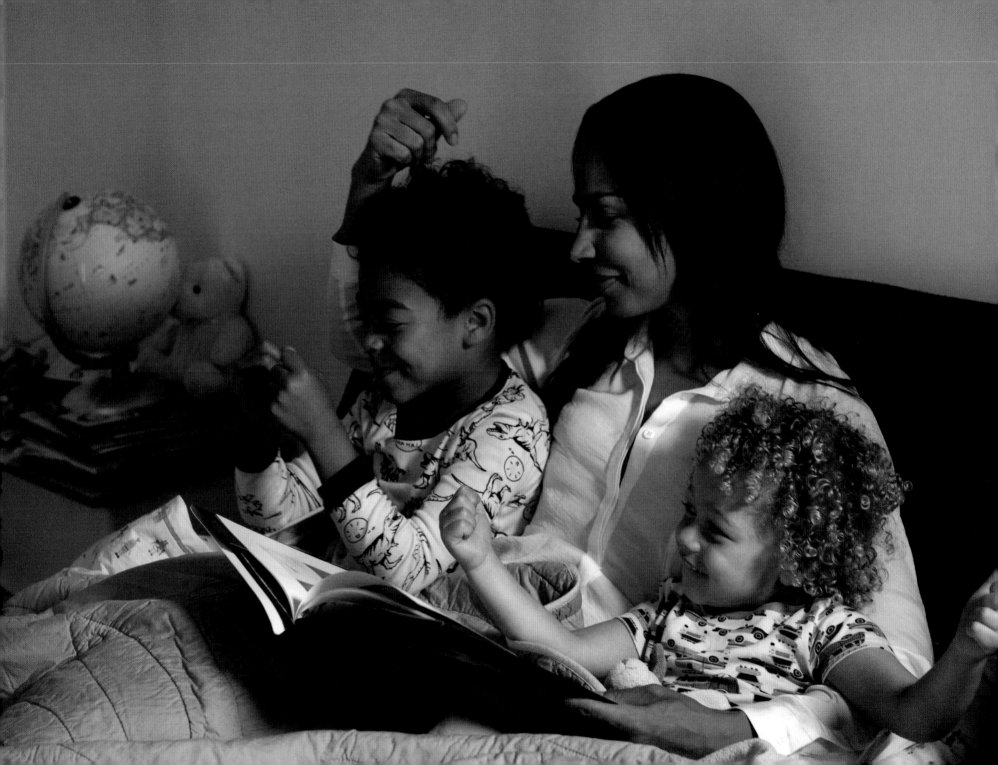

57 EAST 7TH

FEATURING DANIELLE BROOKS

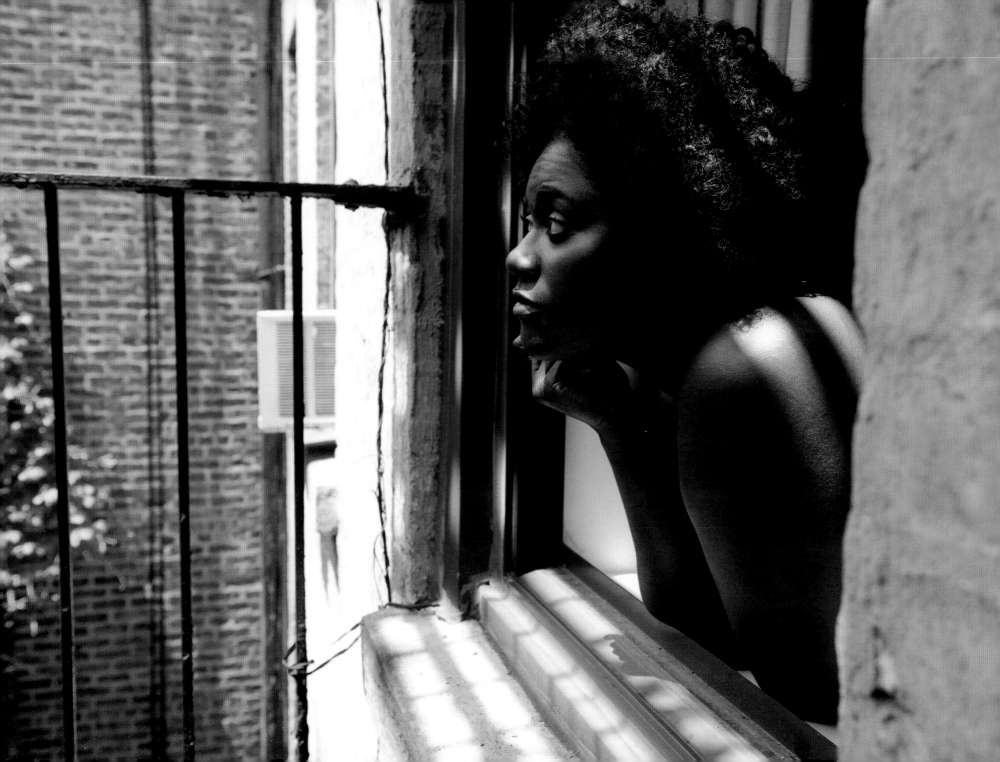

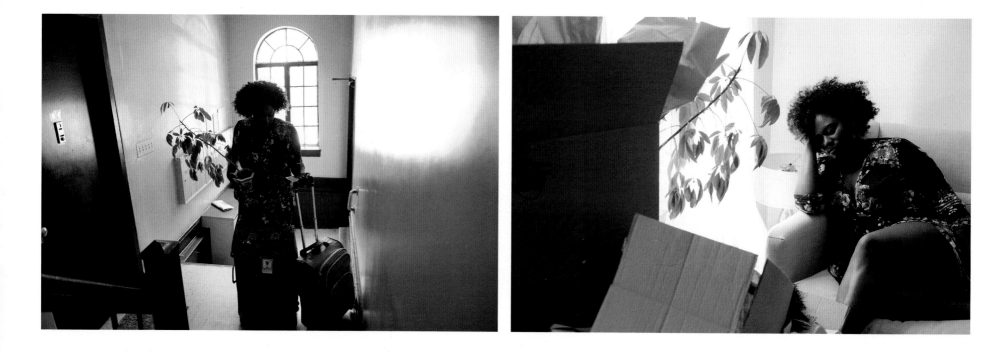

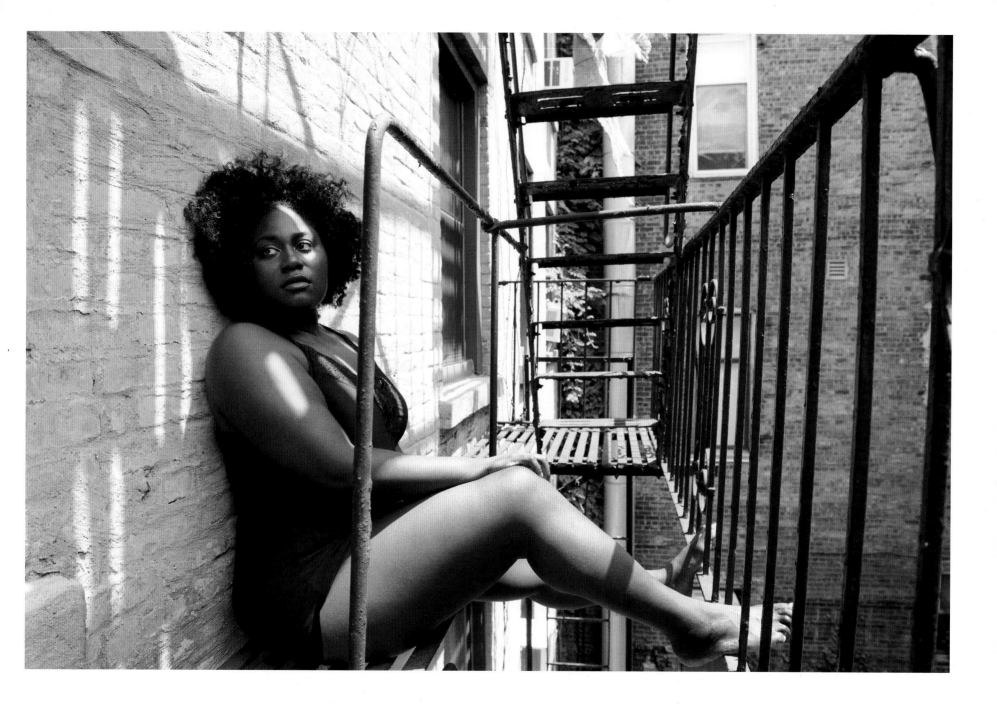

IT WAS A YEAR OF MISTAKES

FEATURING IMOGEN POOTS

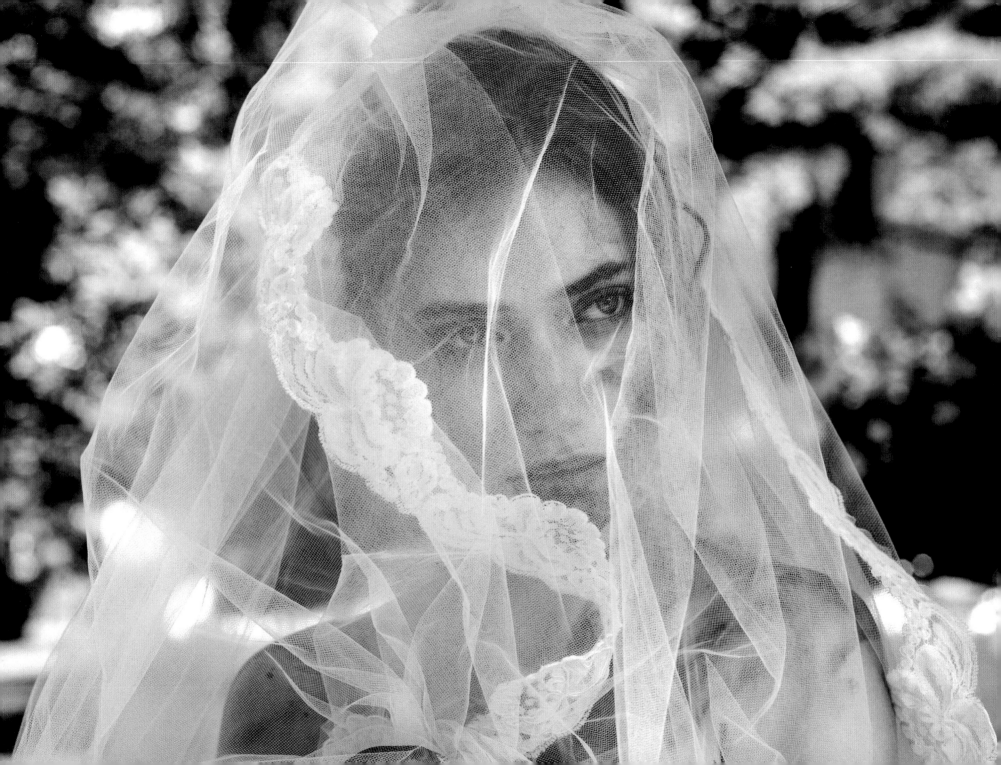

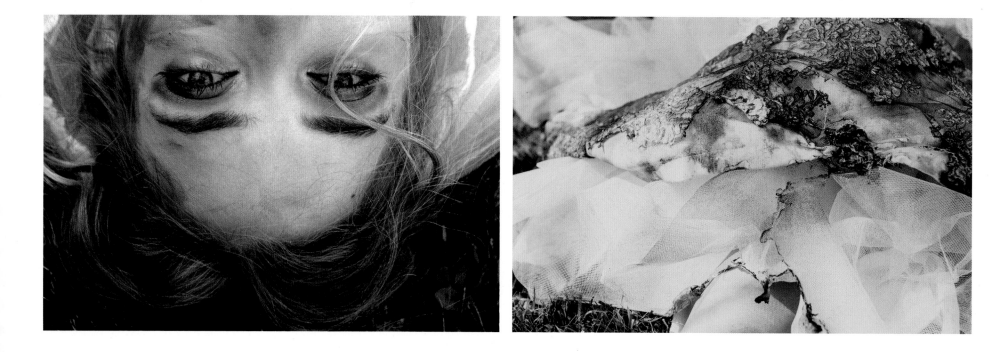

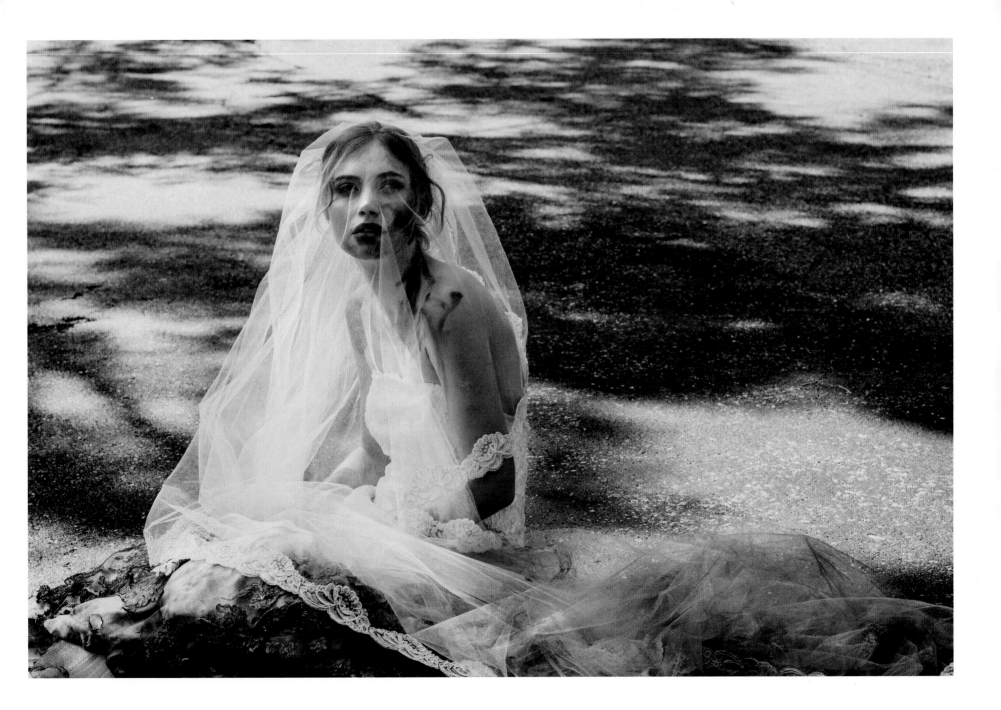

PAST THE LILACS, IN THE CLEARING, MEET ME WHEN IT'S DARK

FEATURING BEL POWLEY

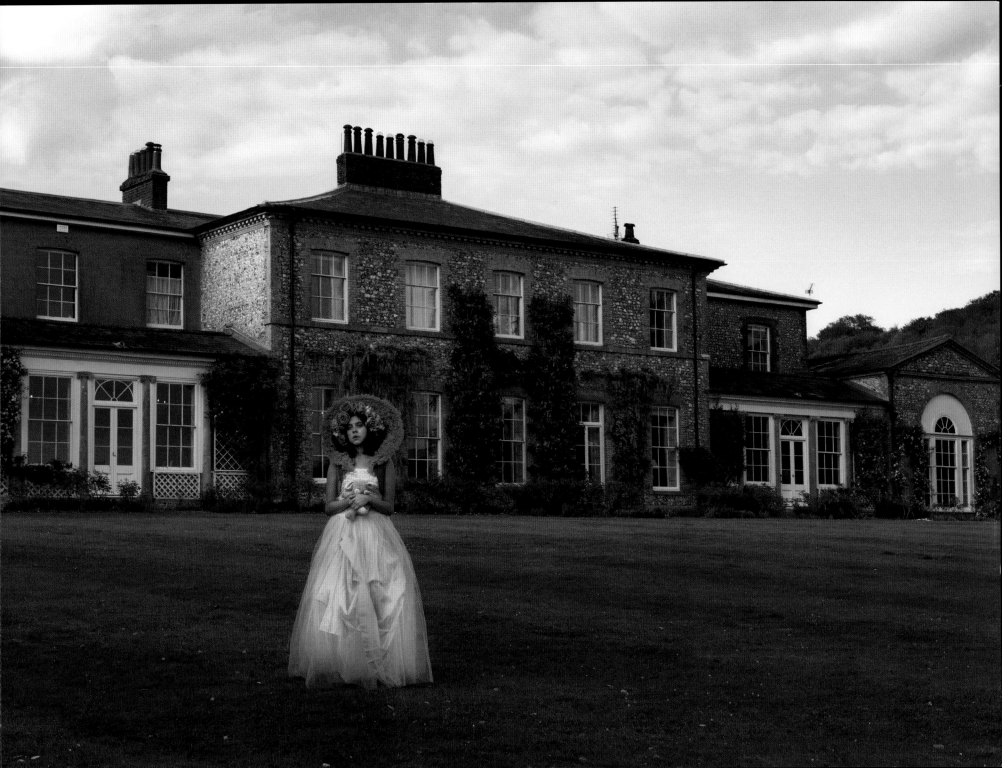

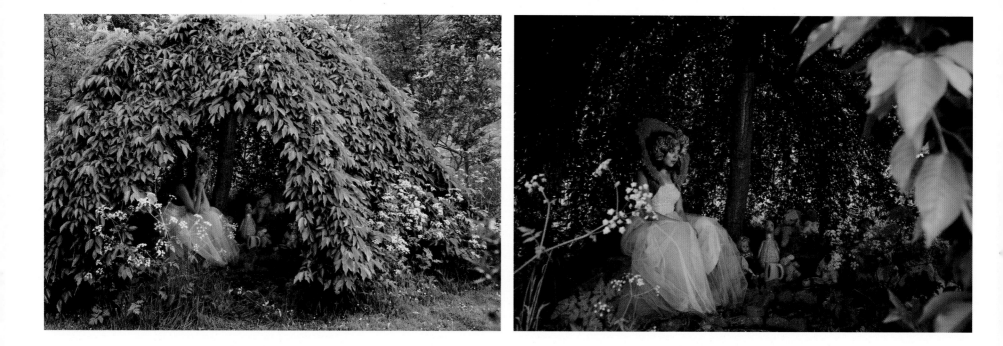

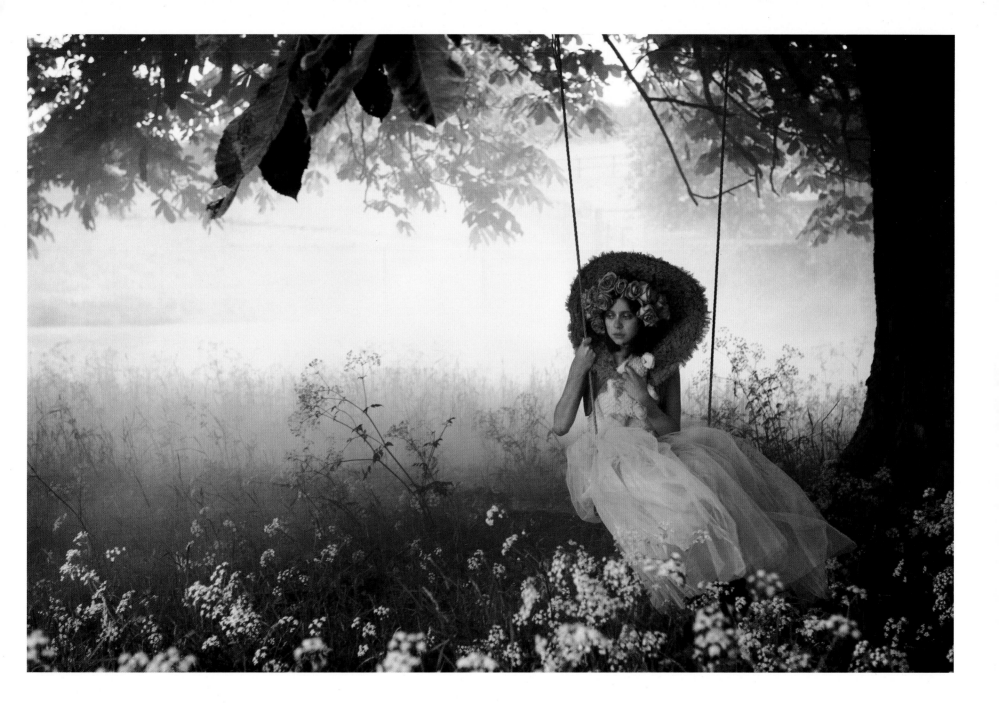

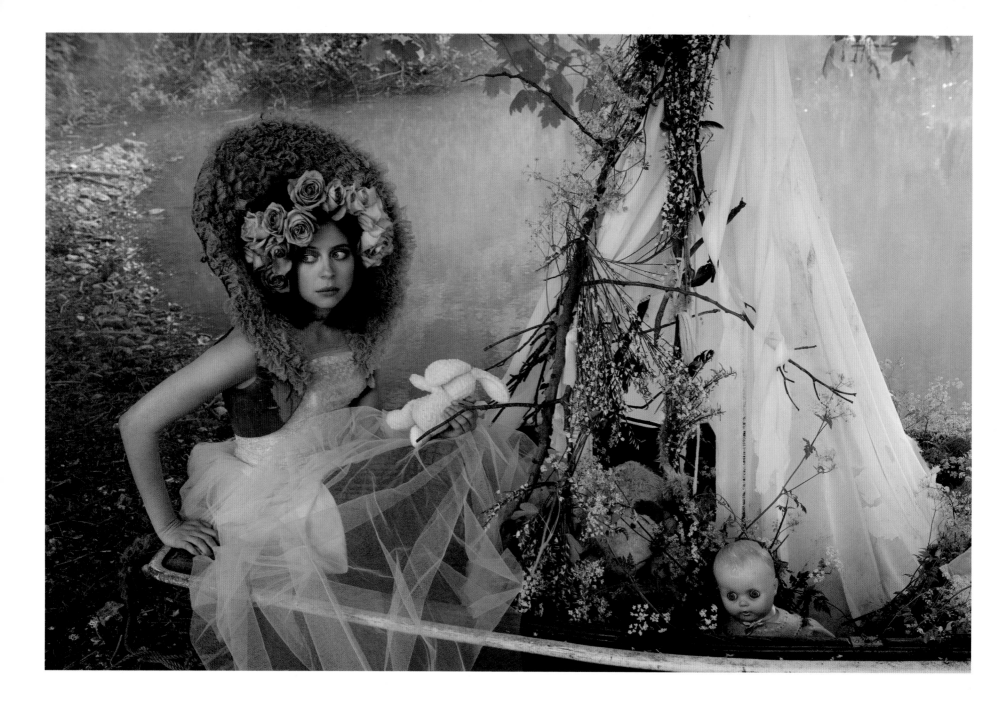

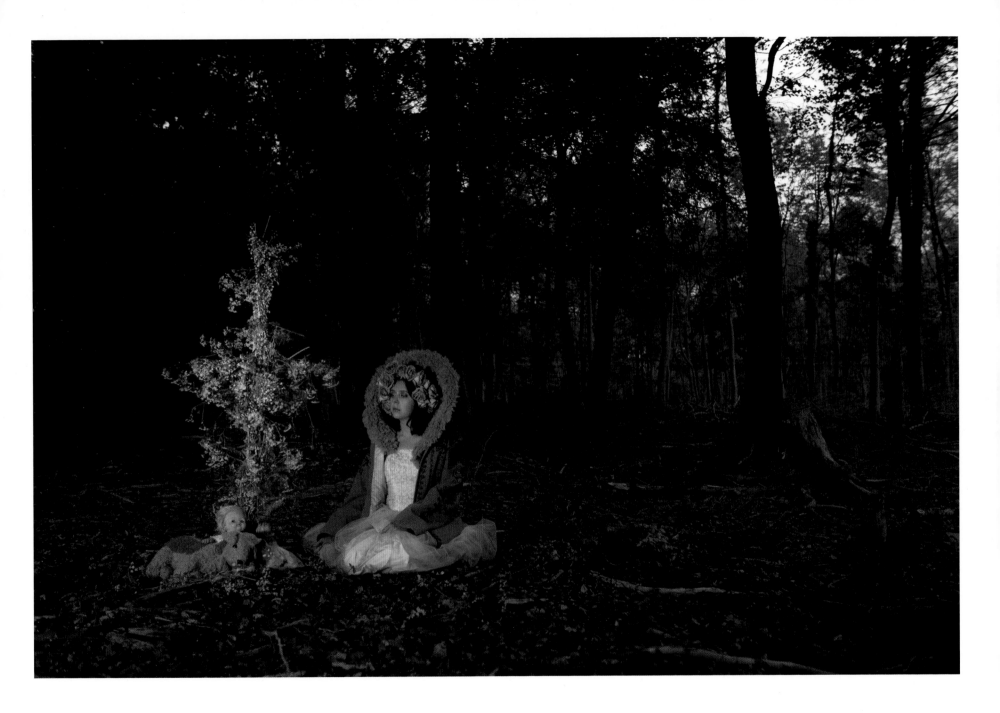

WHAT KIND OF WOMAN

FEATURING TESSA THOMPSON

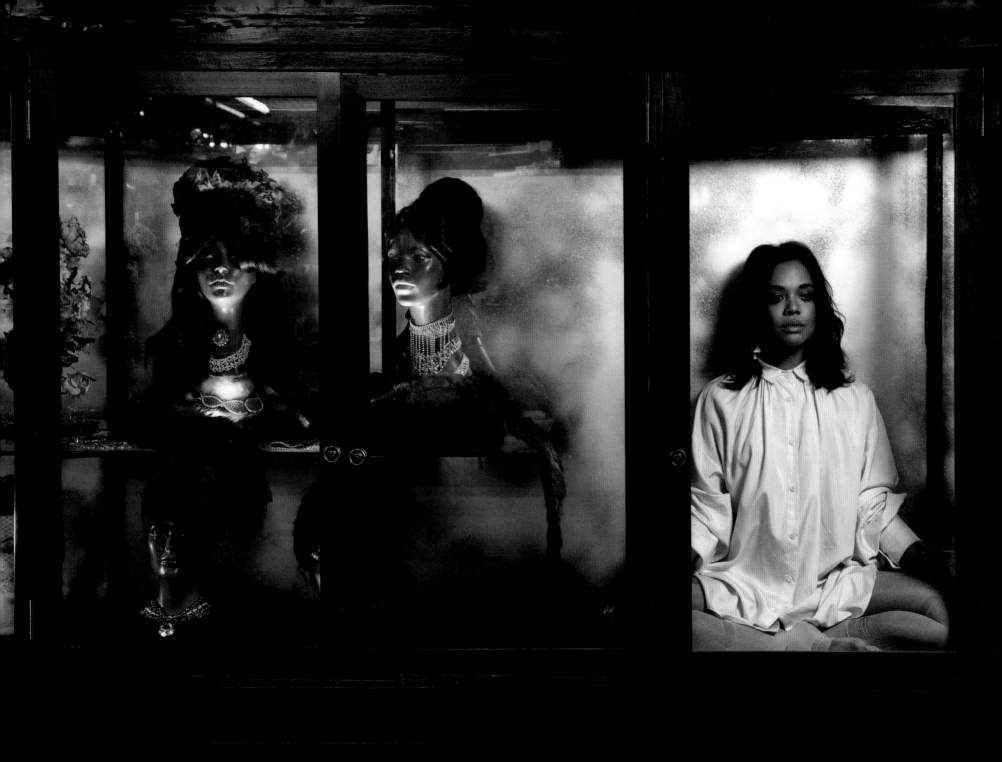

RECKONING

FEATURING EMILY HAMPSHIRE

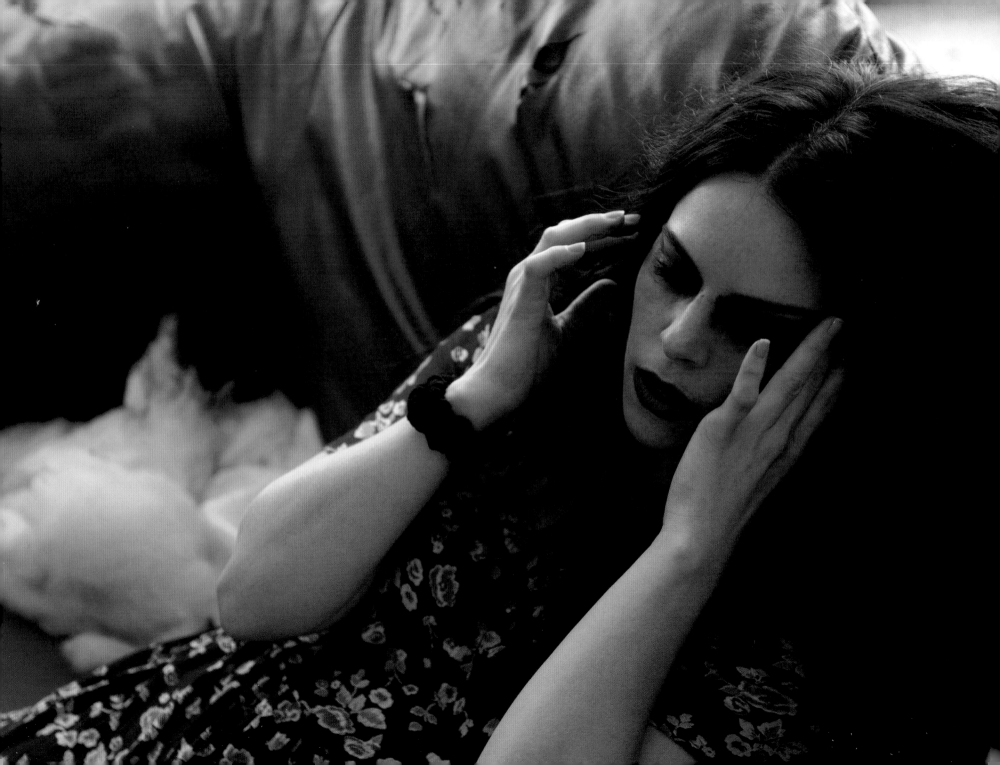

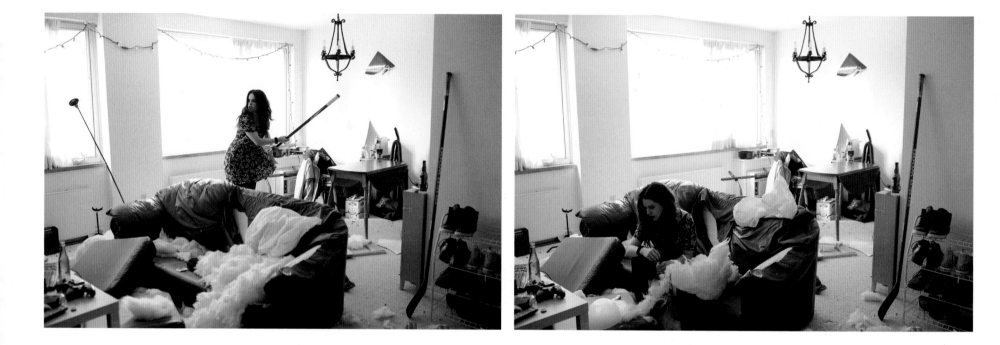

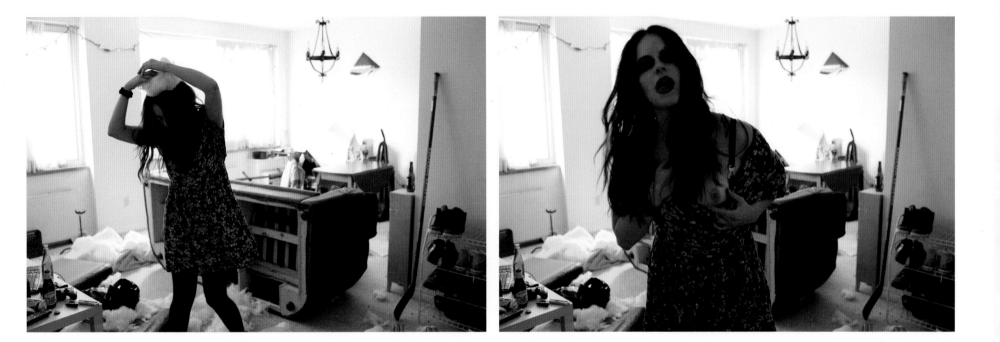

NOT EVERYONE LIES AS EASILY AS YOU

FEATURING SOOK-YIN LEE

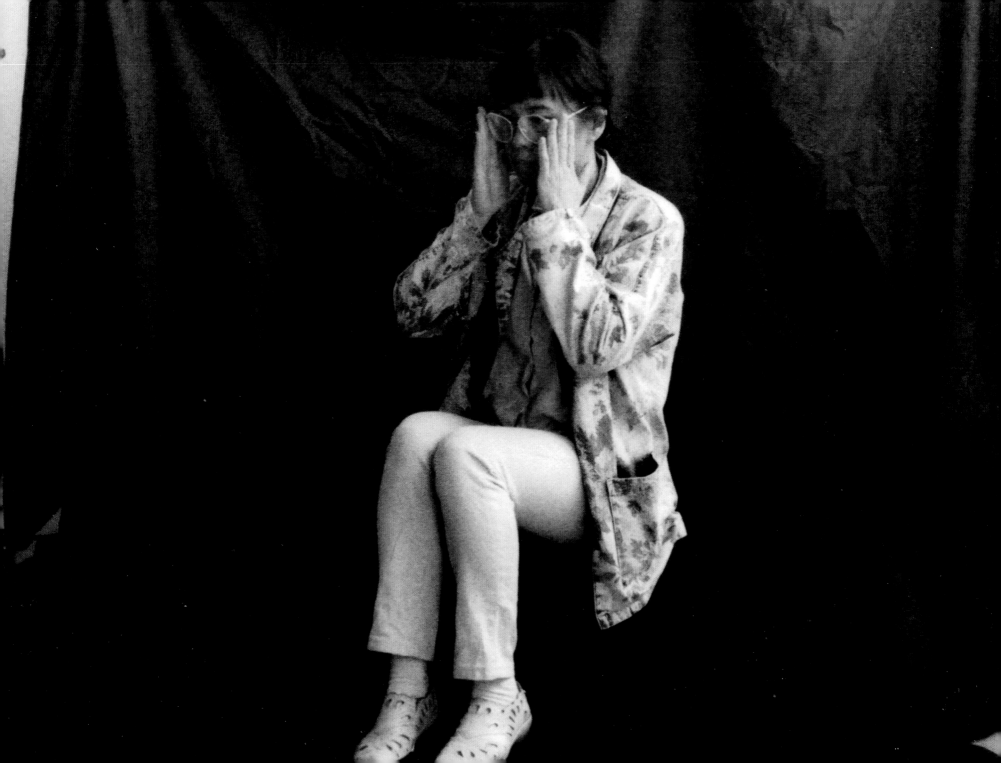

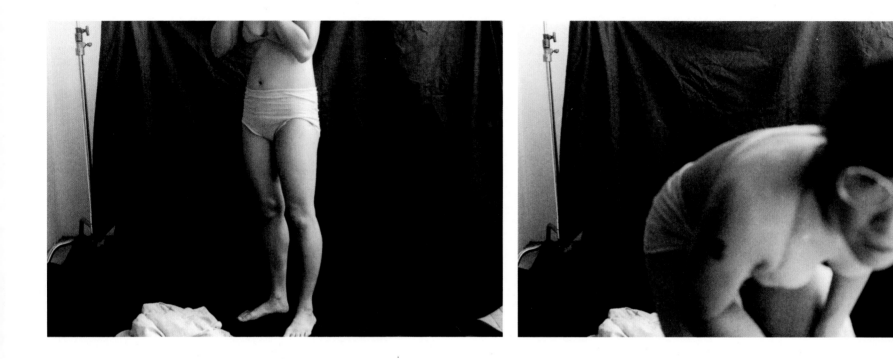

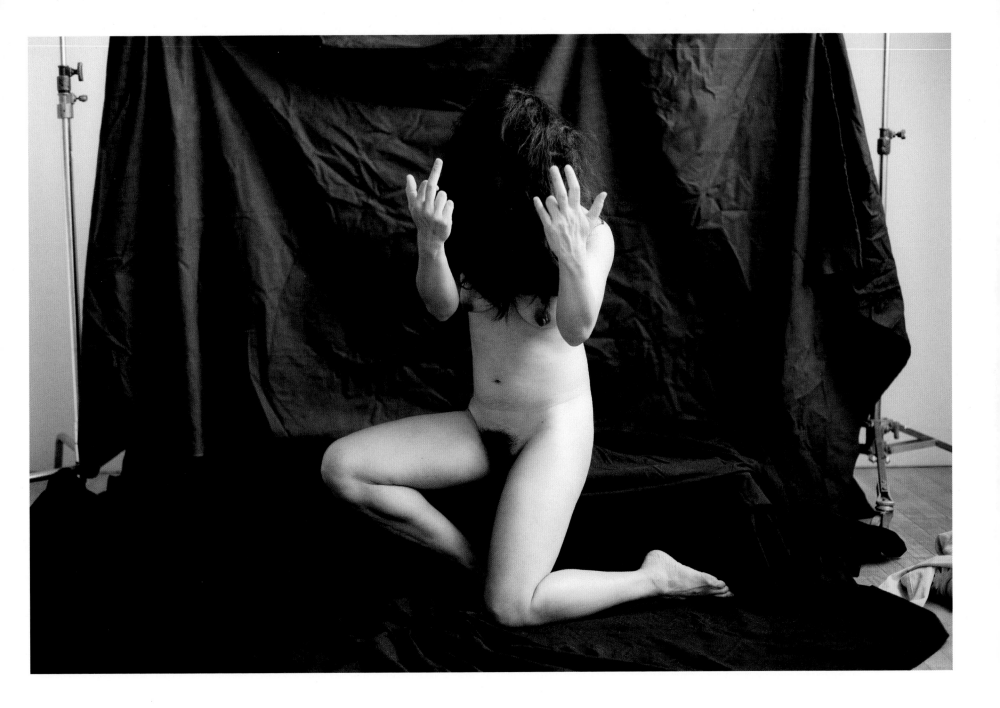

BELOVED, NO. 31
FEATURING ALISON PILL

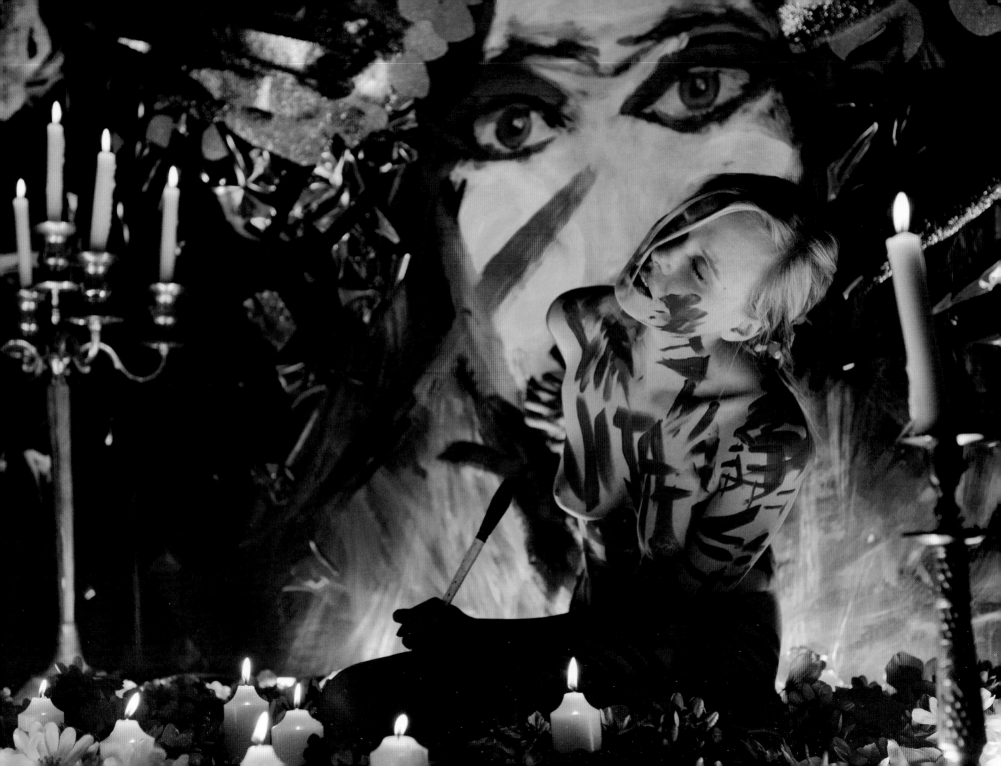

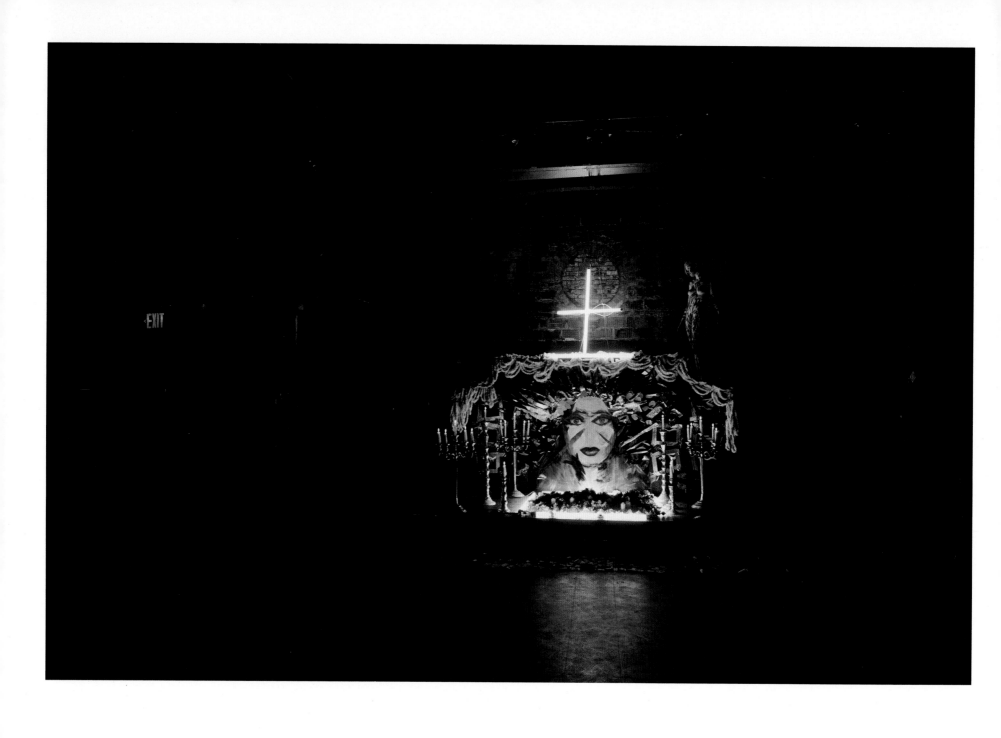

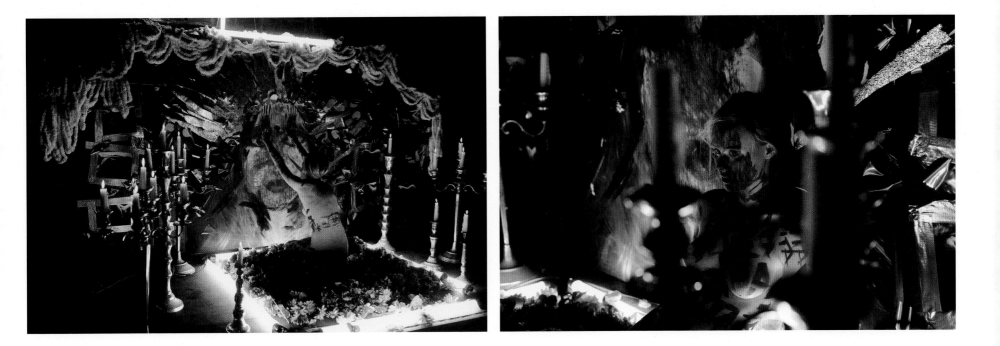

HE'S STAYING IN ASPEN

FEATURING
CHARLOTTE SULLIVAN

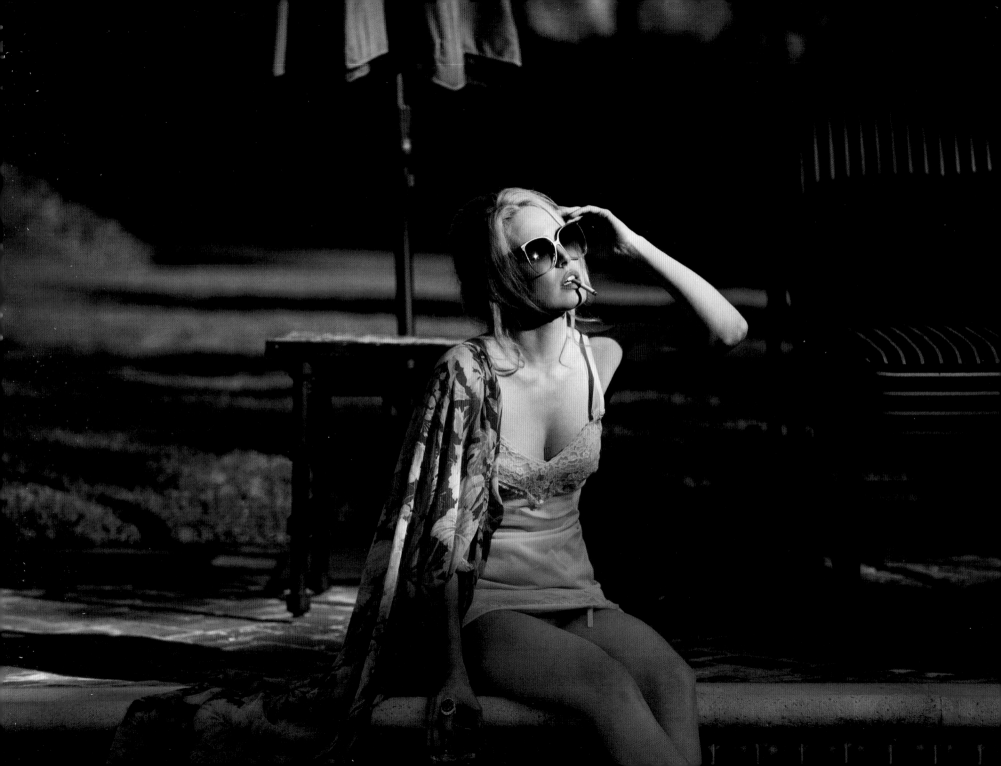

WHEN TEARS ARE IN YOUR EYES

FEATURING CHRISTINE HORNE

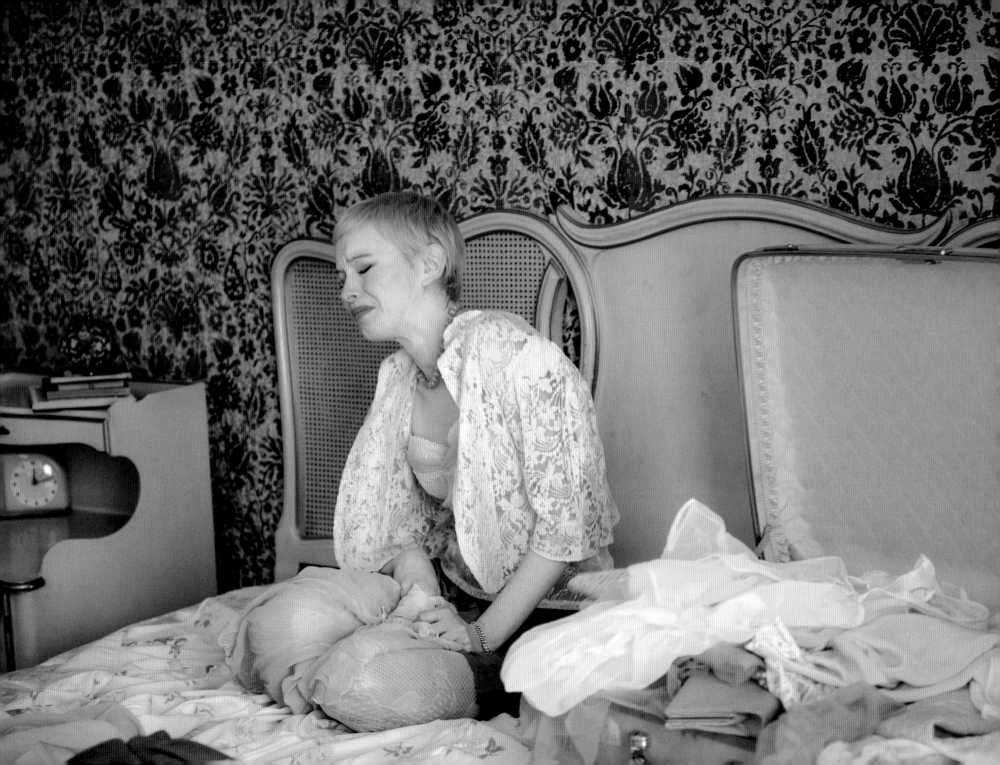

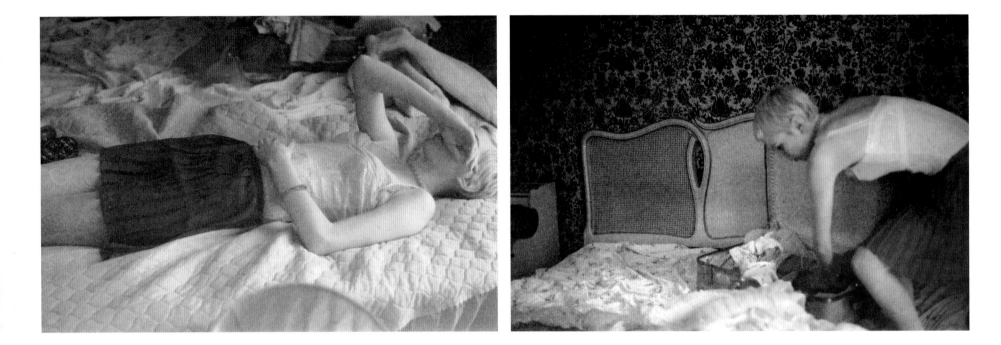

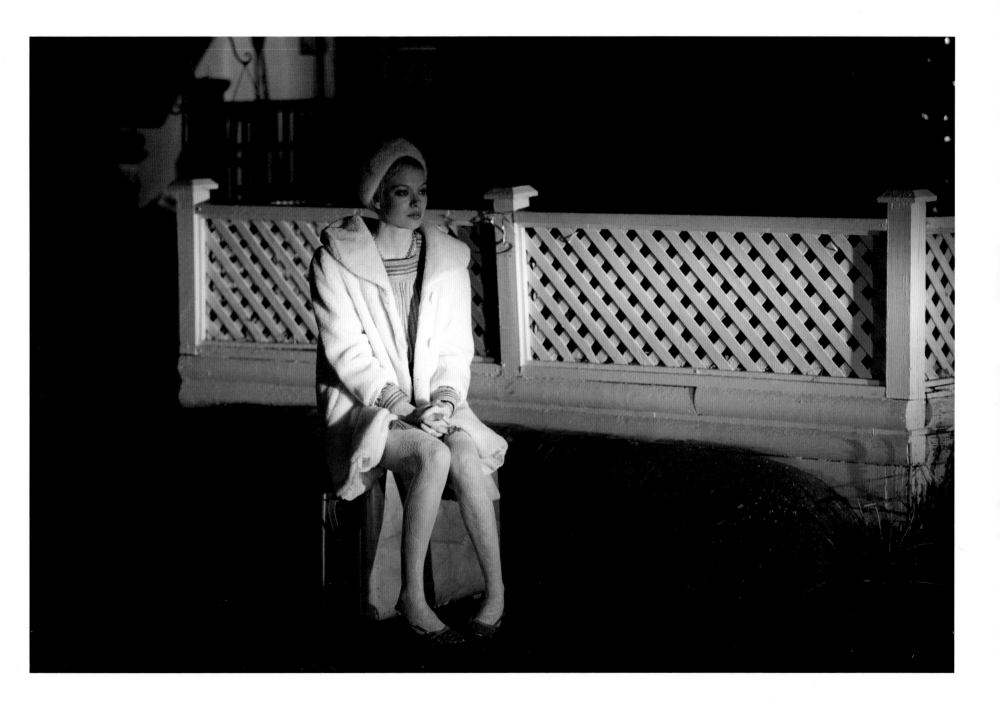

TELL ME HER NAME
FEATURING GUGU MBATHA-RAW

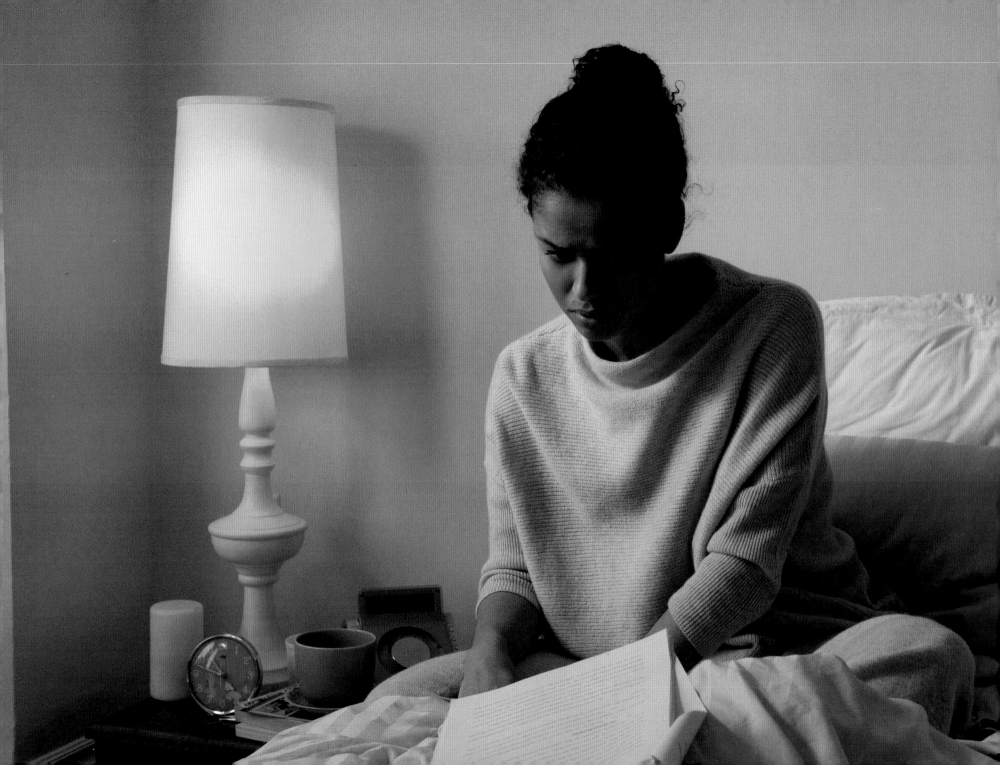

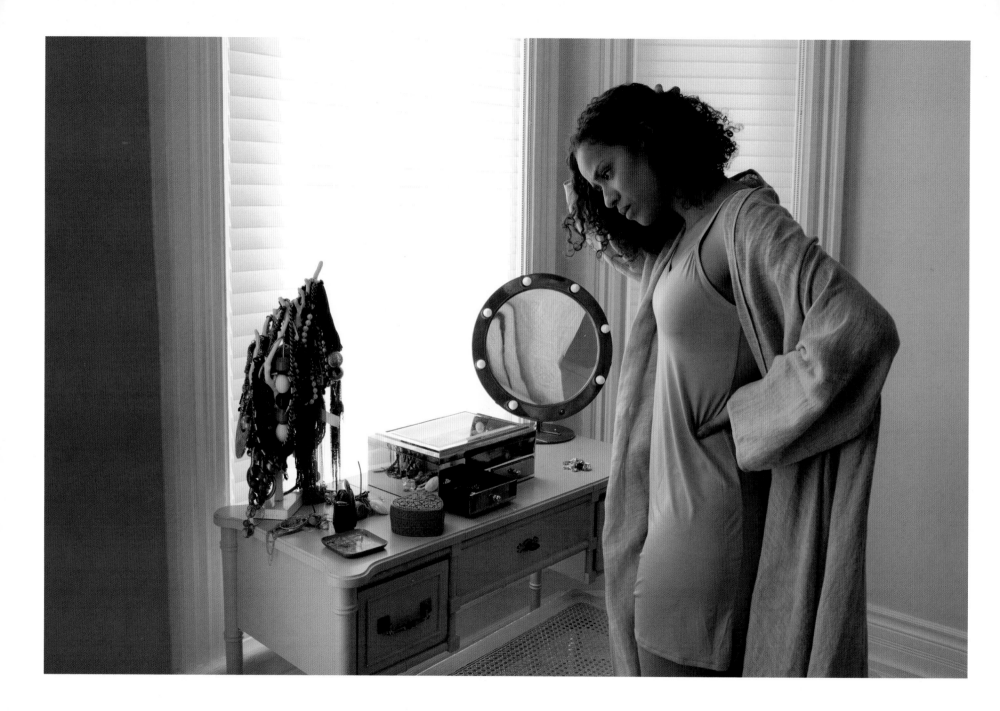

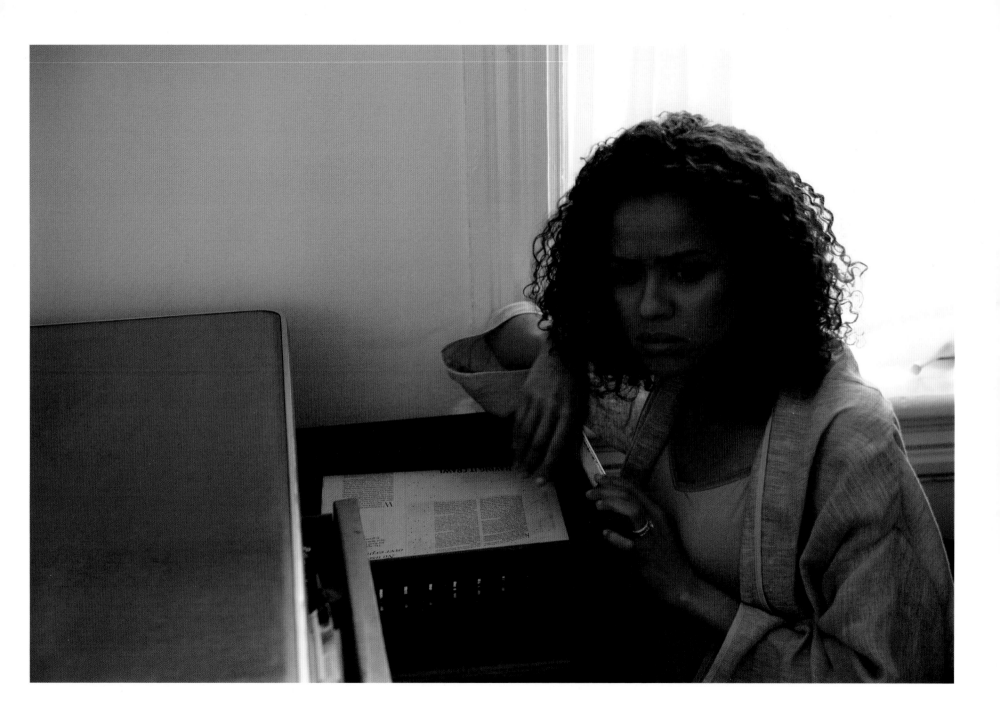

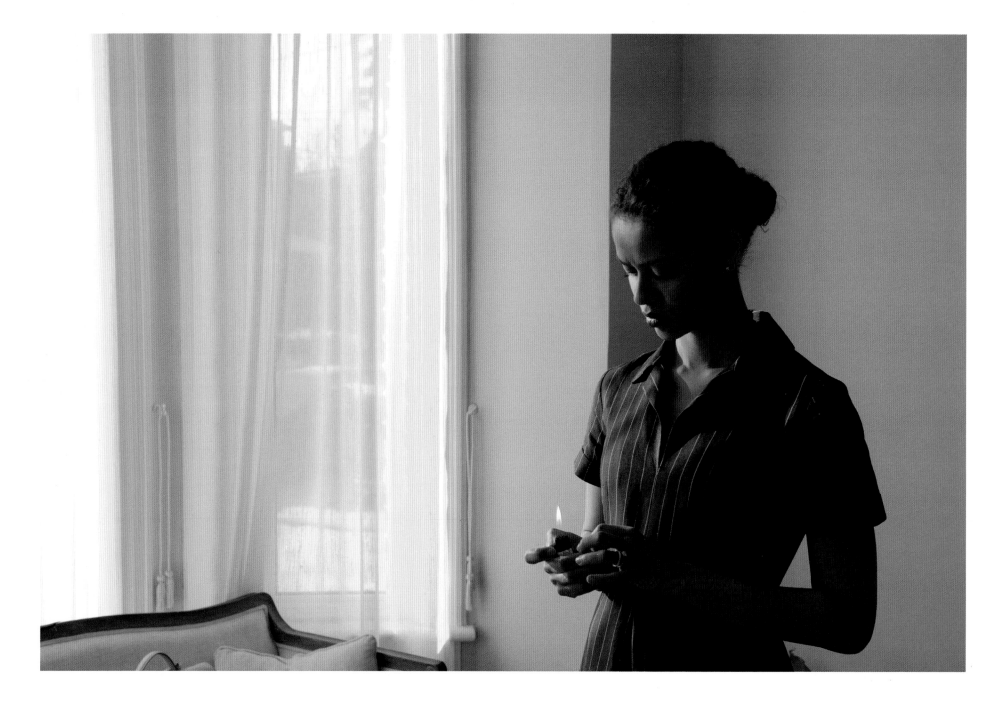

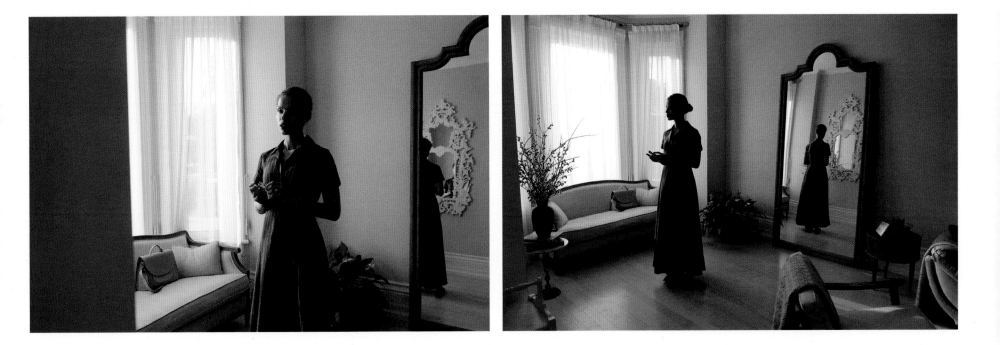

YOUR ACCENT, THE WAY YOU PLAY PIANO, YOUR MOTORCYCLE

FEATURING NINA DOBREV

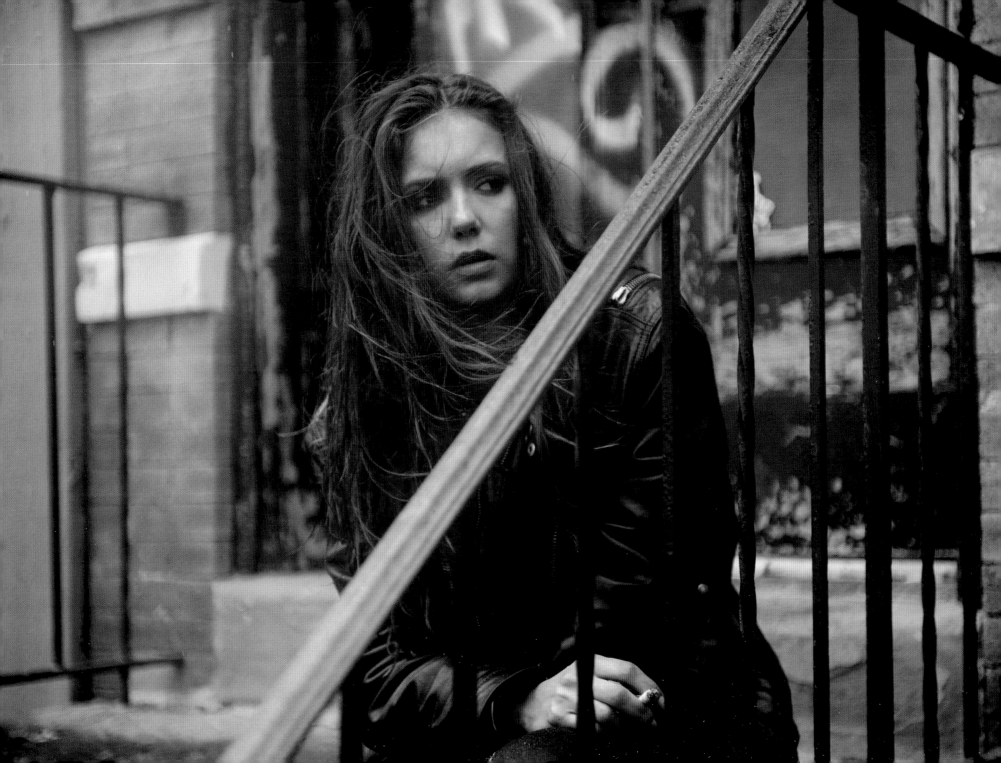

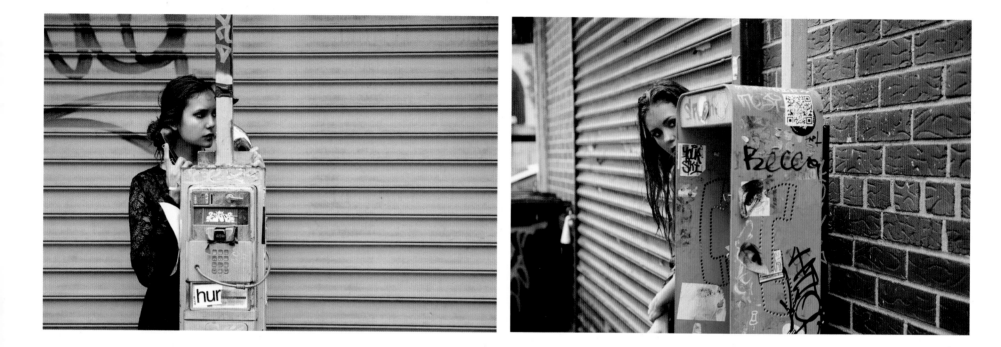

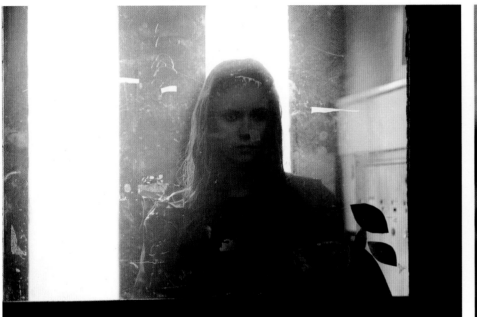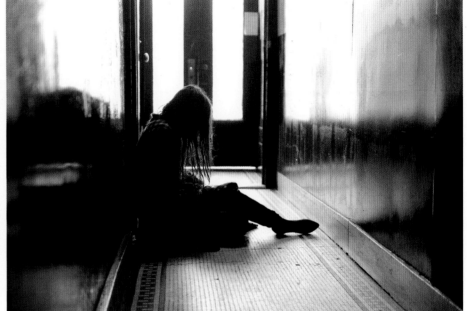

A HEALTHY AMOUNT OF DELUSION

FEATURING MALIN AKERMAN

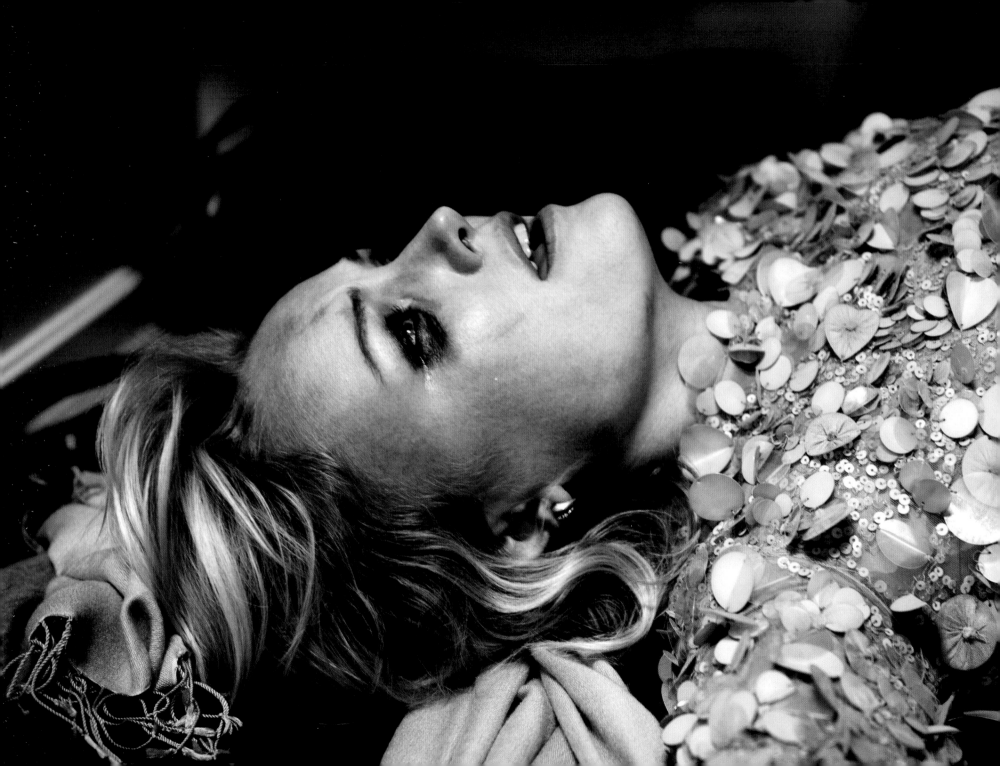

STAY HIGH

FEATURING JUNO TEMPLE

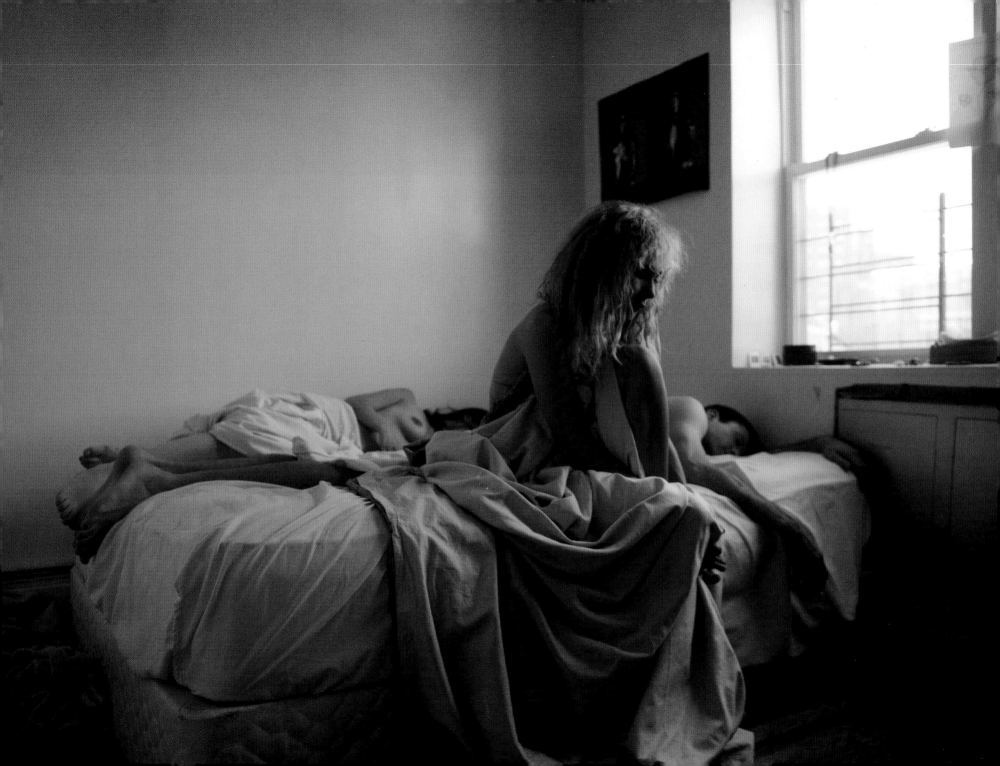

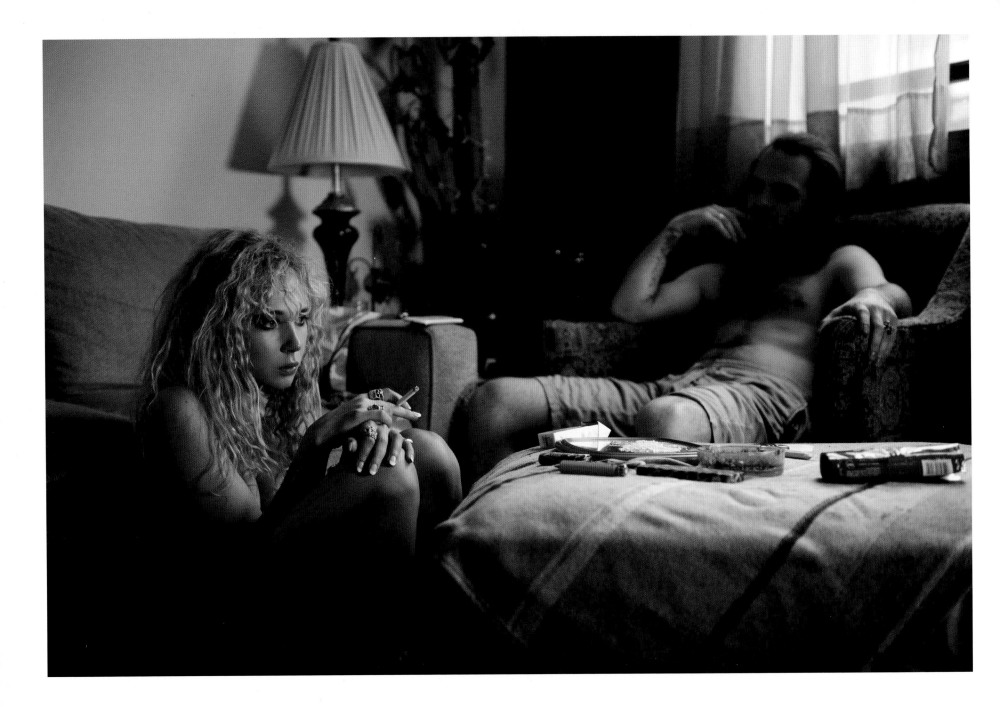

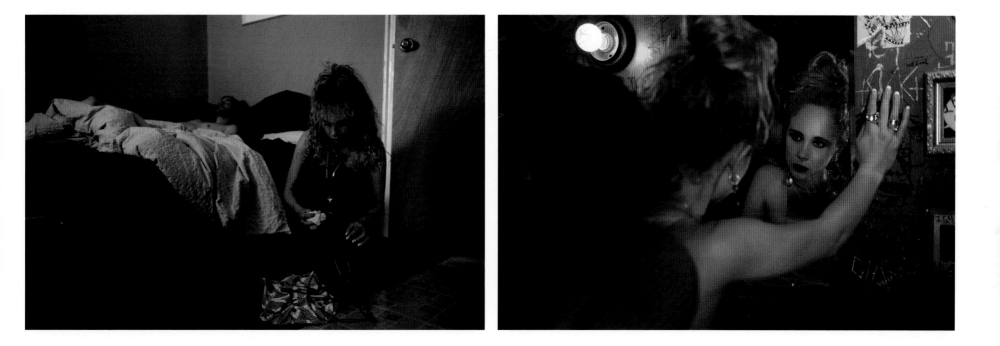

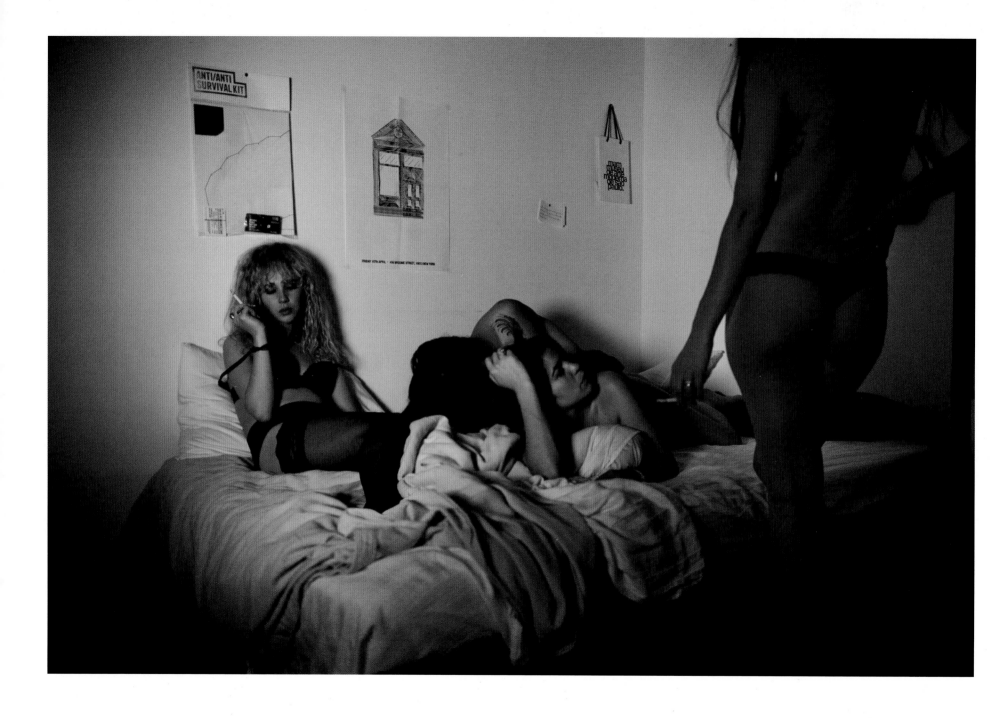

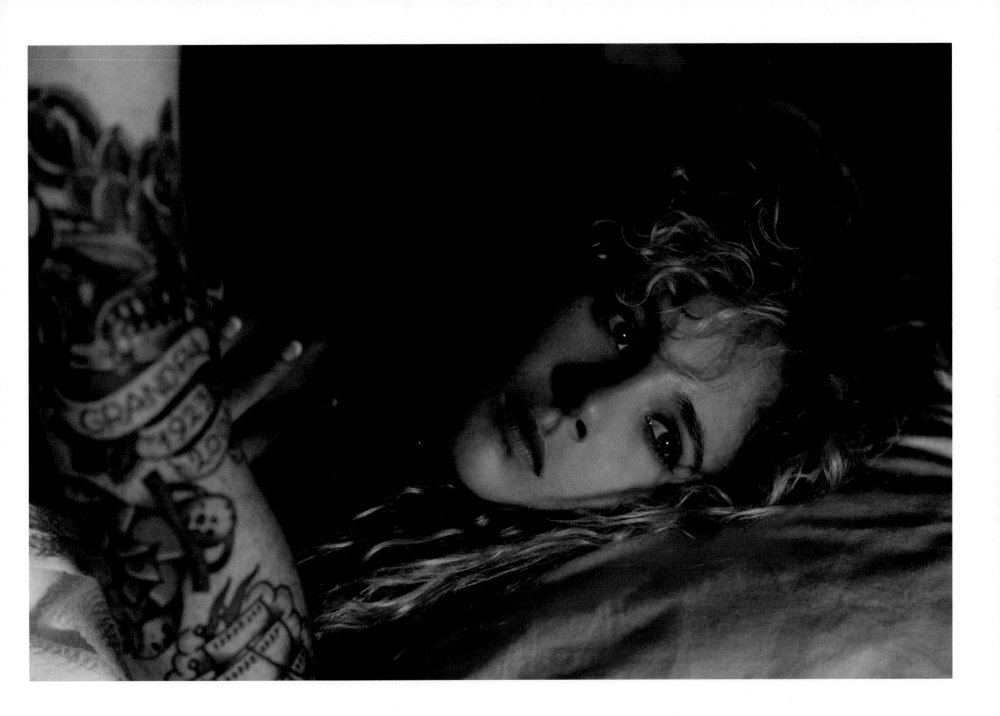

QUEEN OF SPADES, QUEEN OF SPADES, FEATURING CARMEN EJOGO

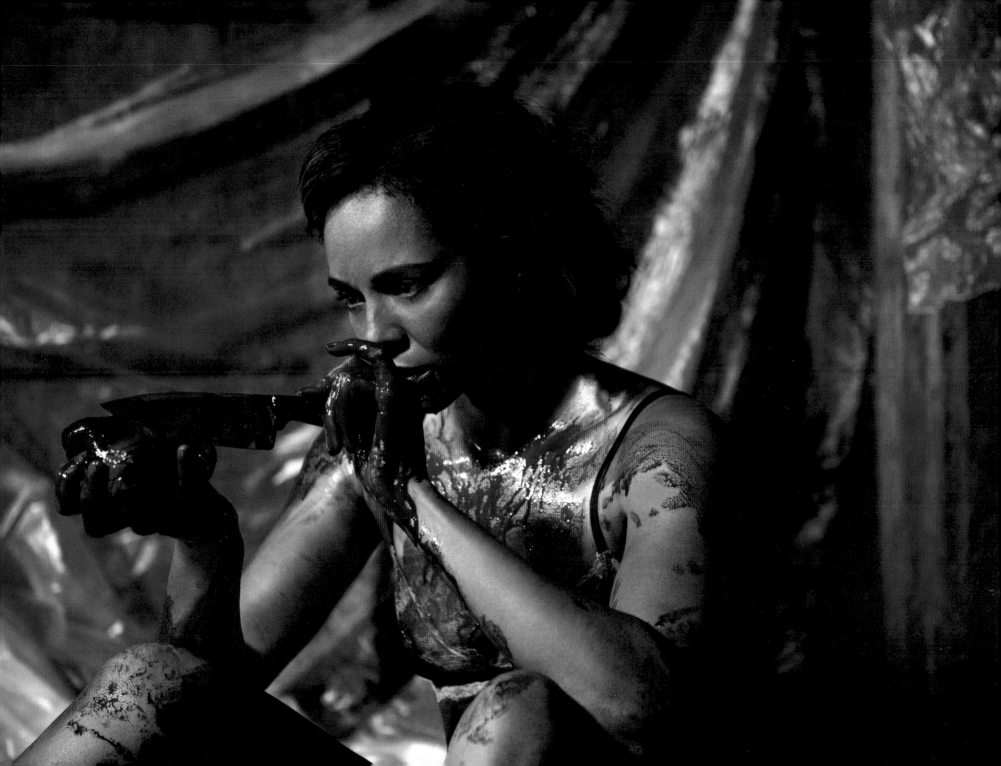

I TOLD HIM NEVER TO CONTACT ME AGAIN

FEATURING
PATRICIA CLARKSON

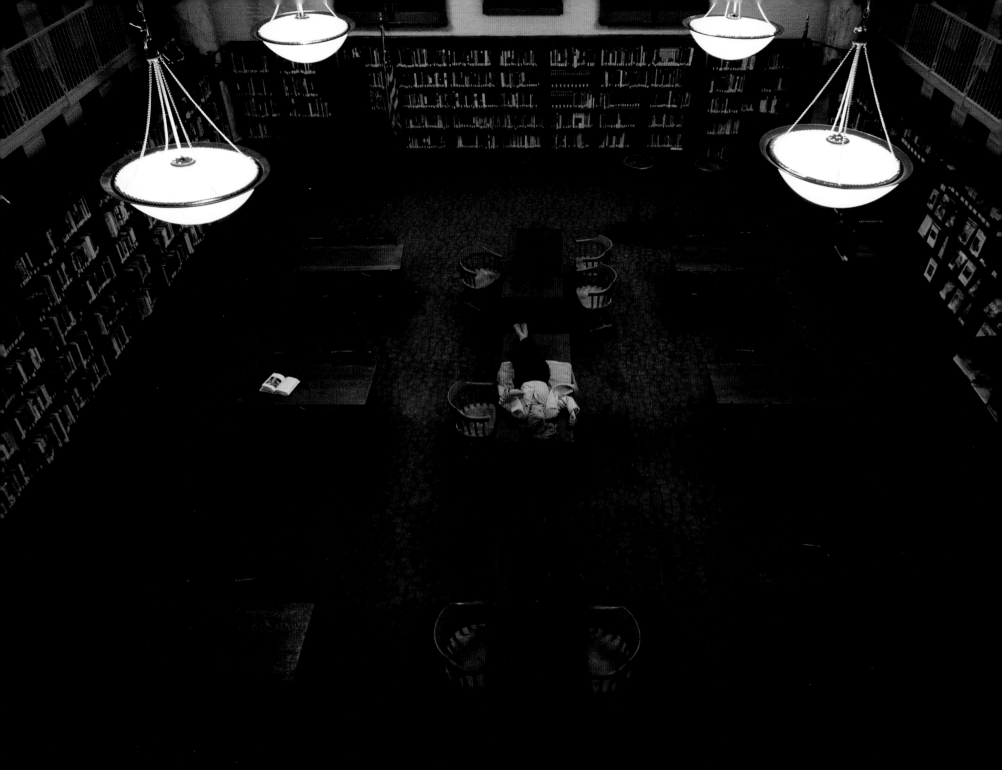

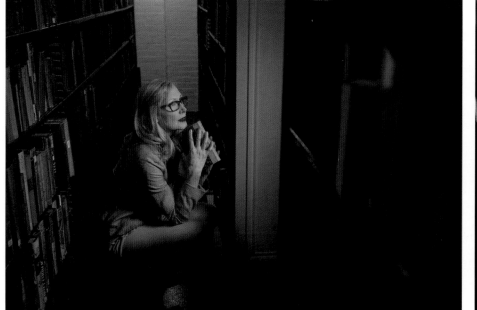
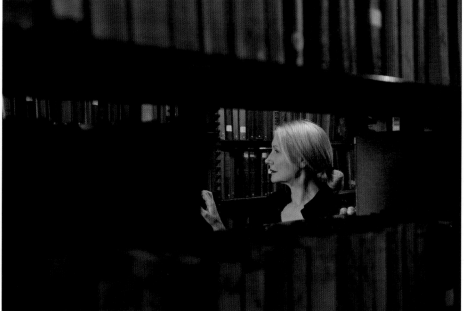

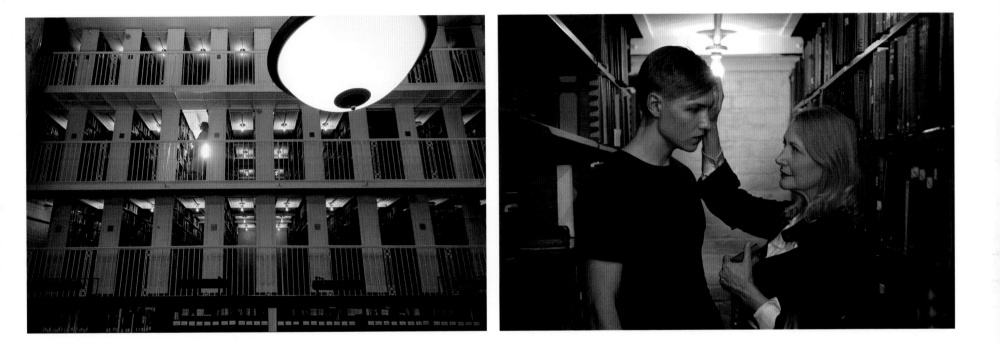

TELL ME TO GO

FEATURING TATIANA MASLANY

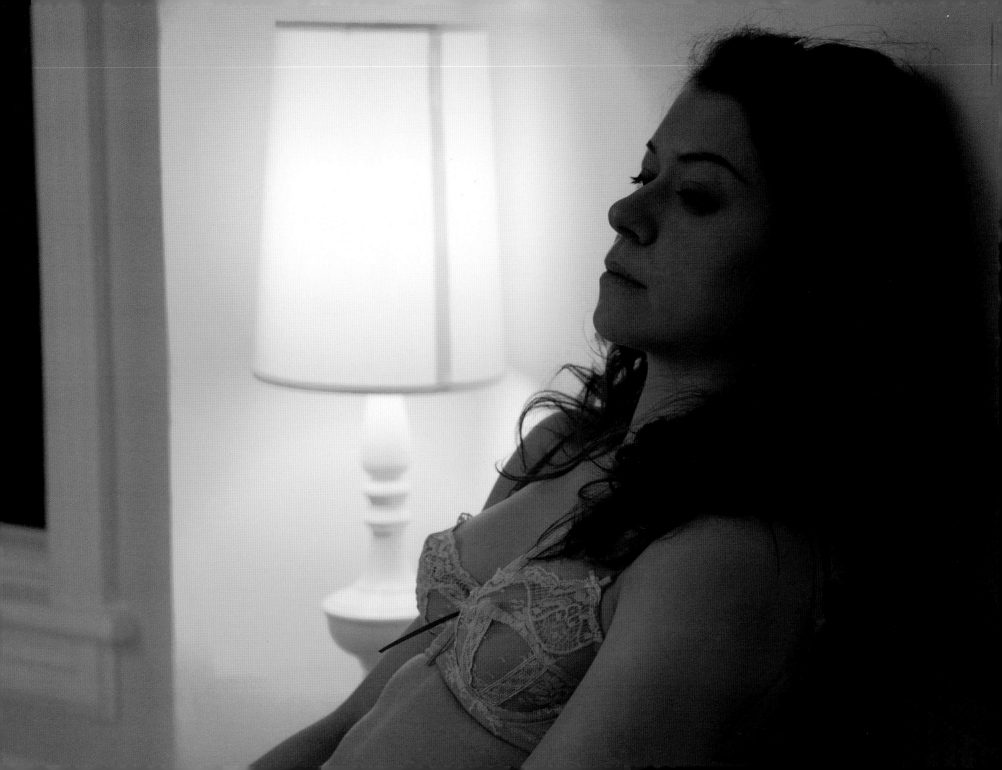

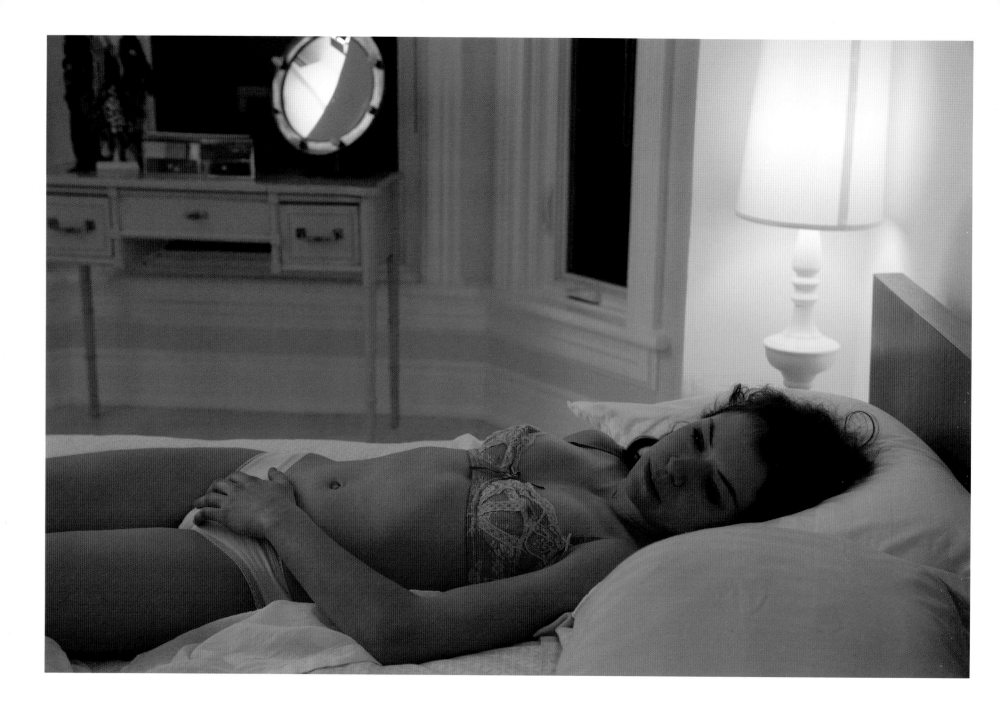

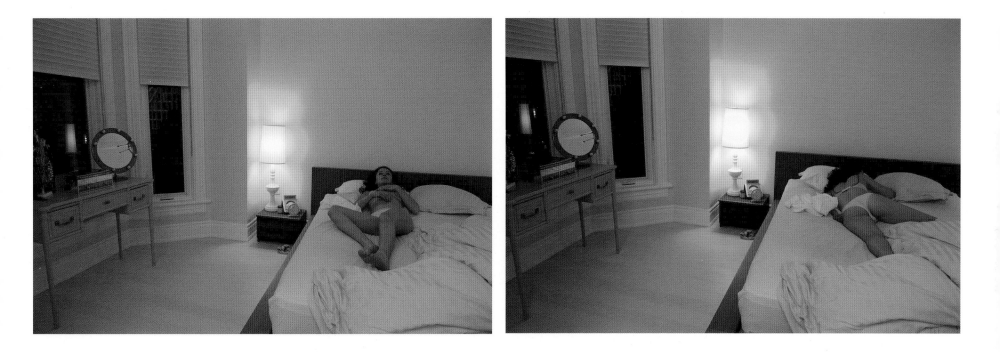

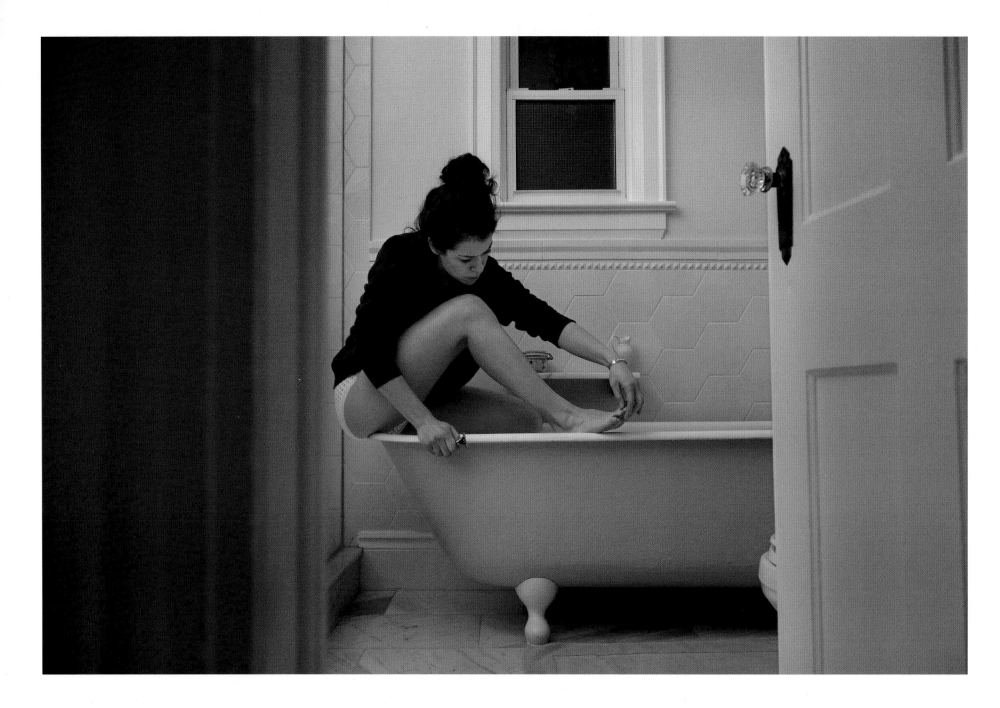

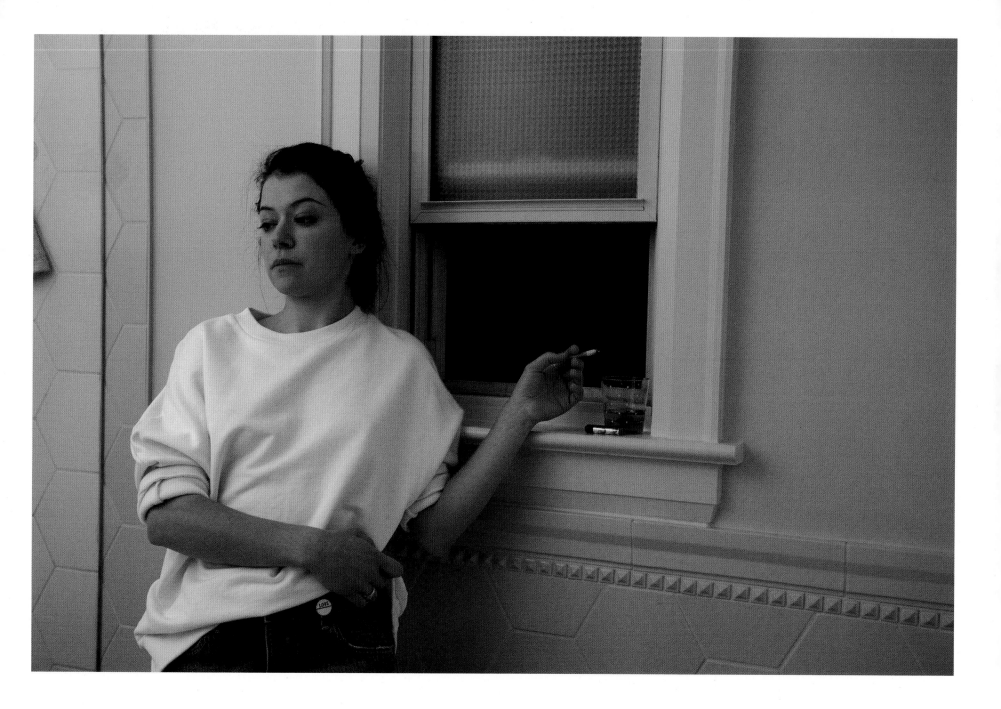

I FEEL HIM

FEATURING PAZ DE LA HUERTA

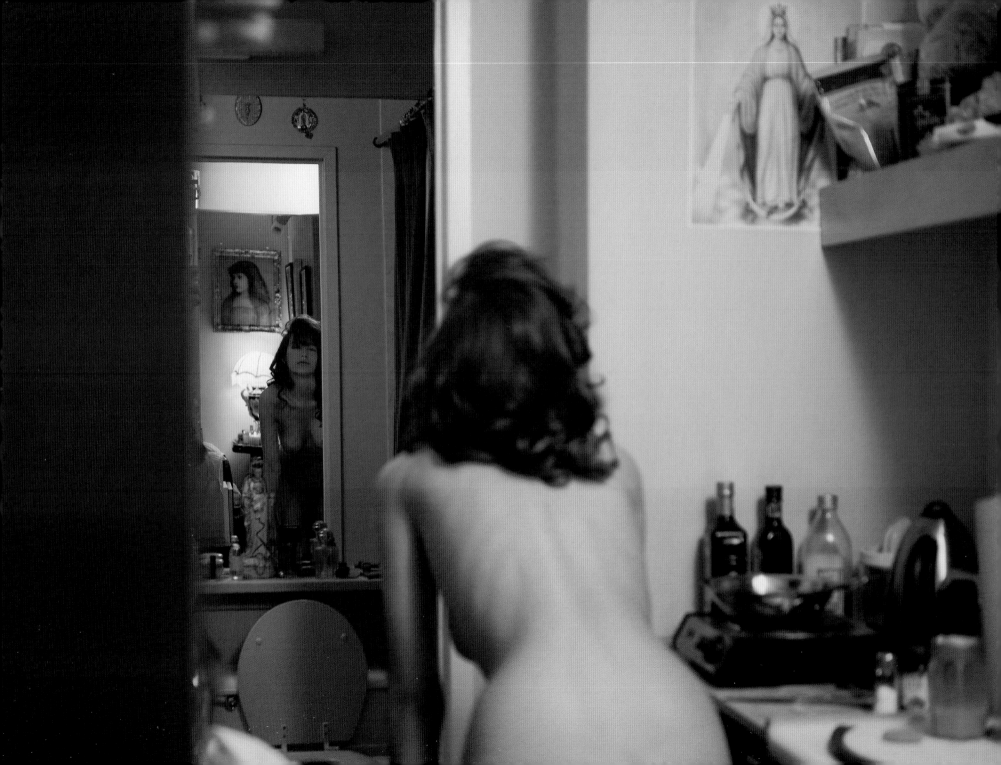

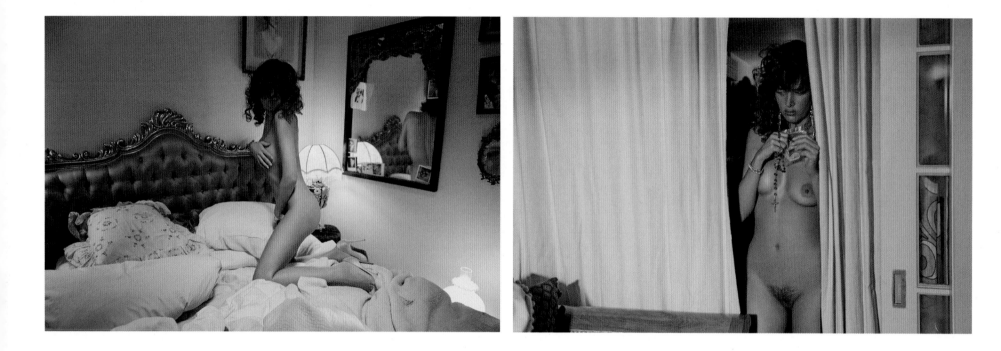

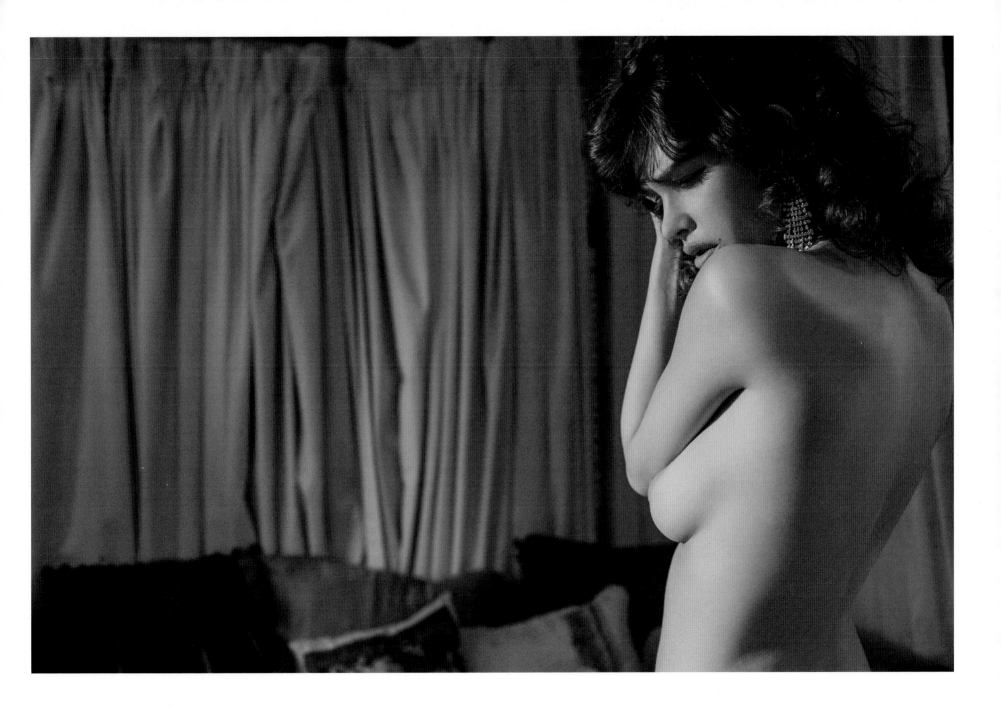

BEGIN AGAIN

FEATURING
JENNIFER JASON LEIGH

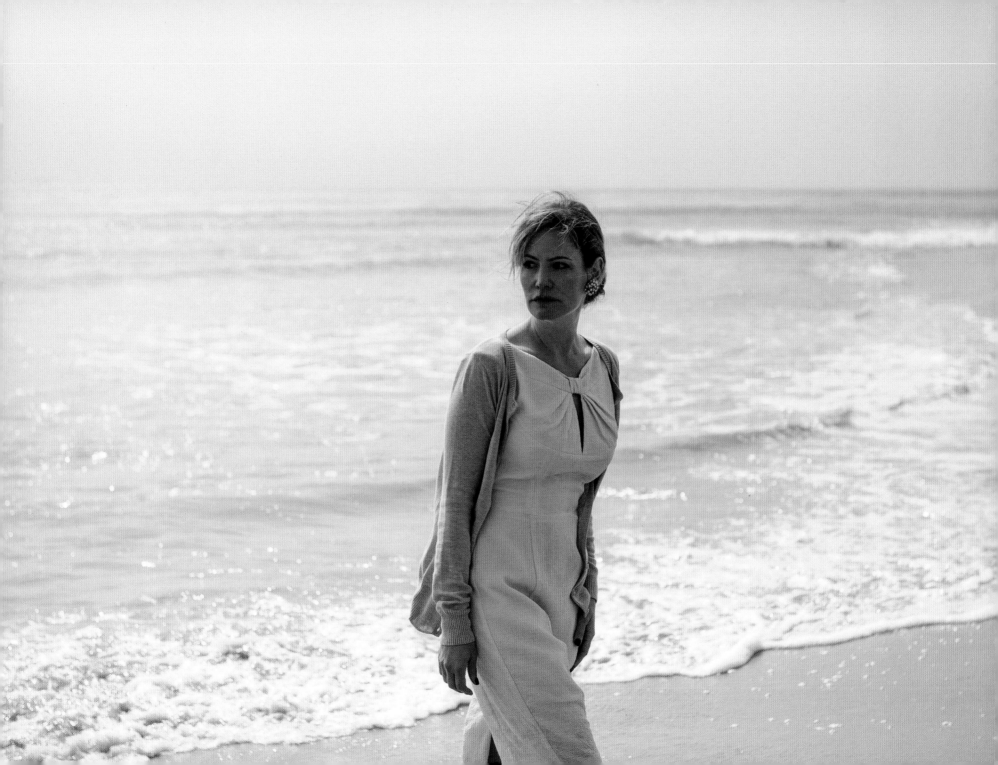

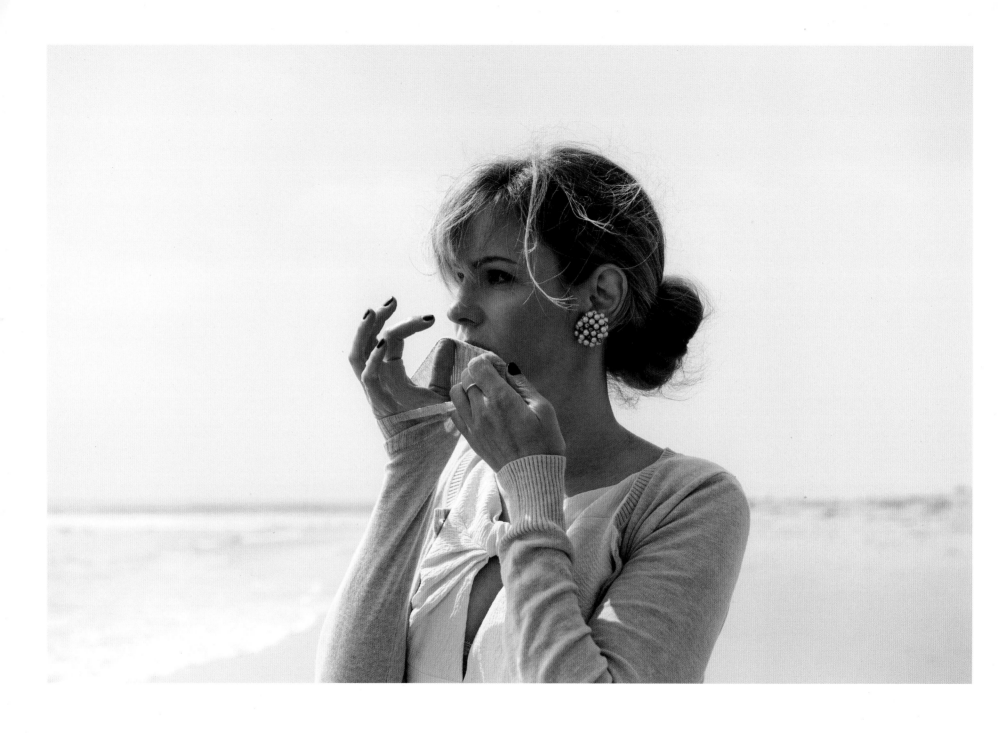

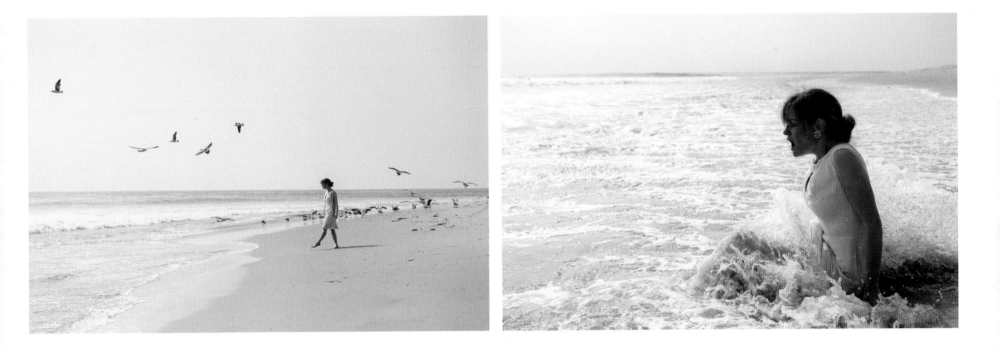

LONELINESS WAS A PLACE I DIDN'T WANT TO GO BACK TO

FEATURING KEIRA KNIGHTLEY

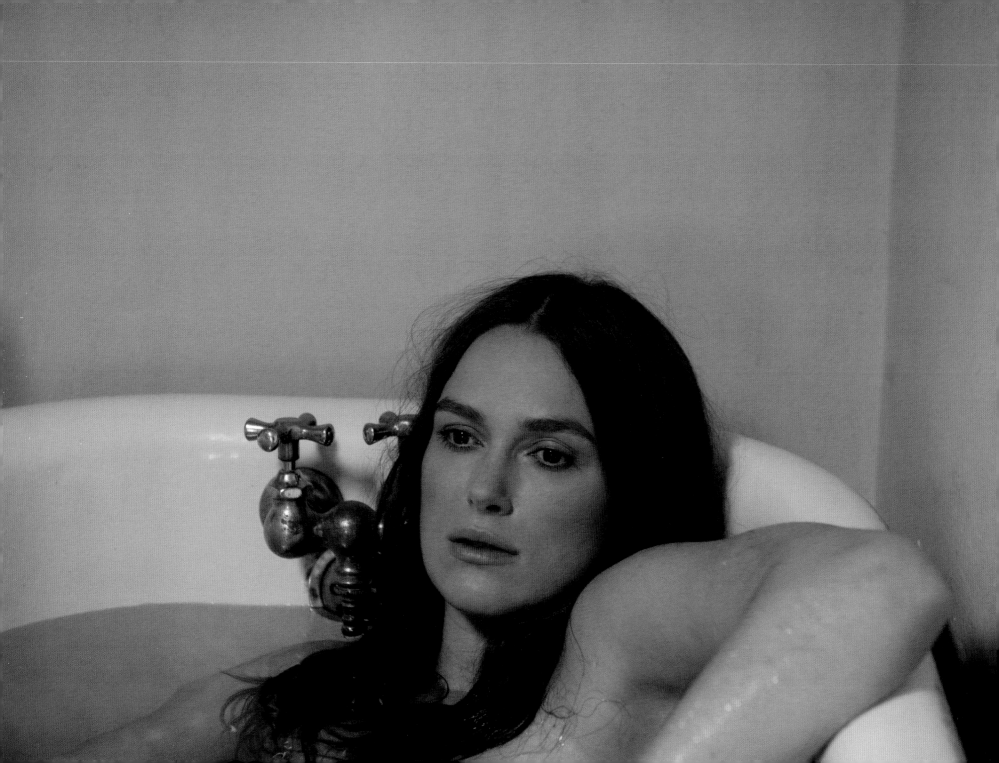

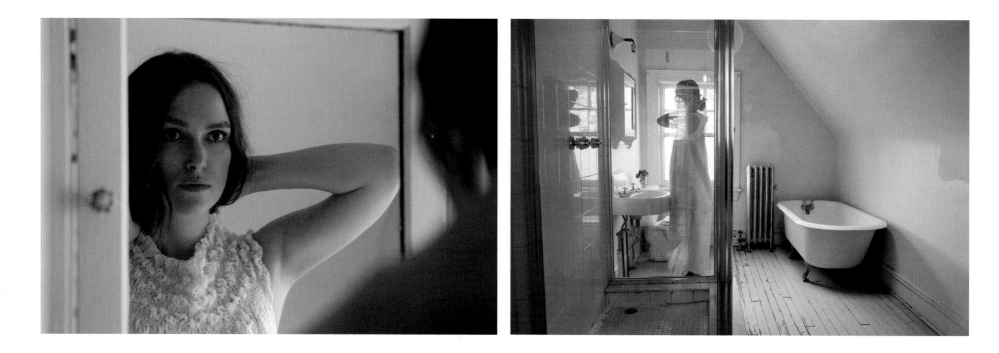

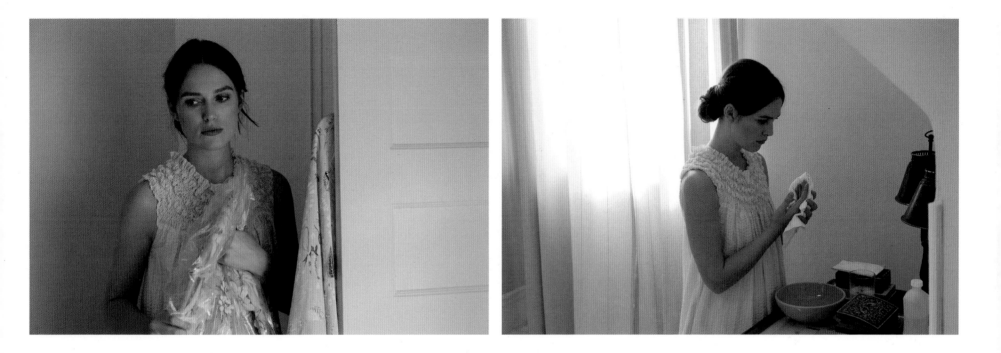

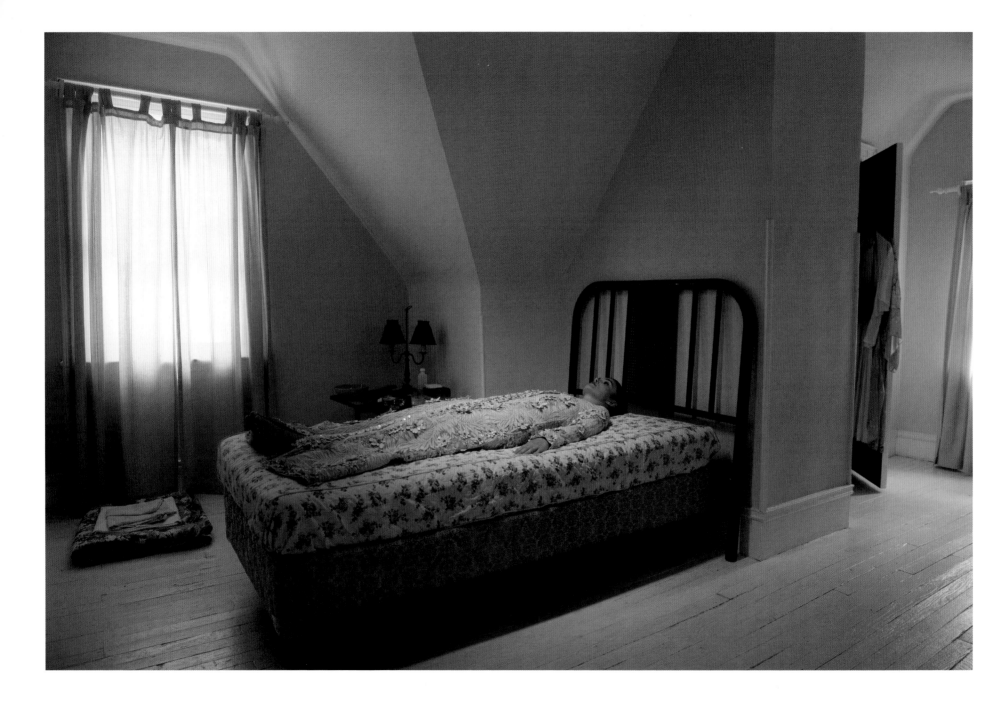

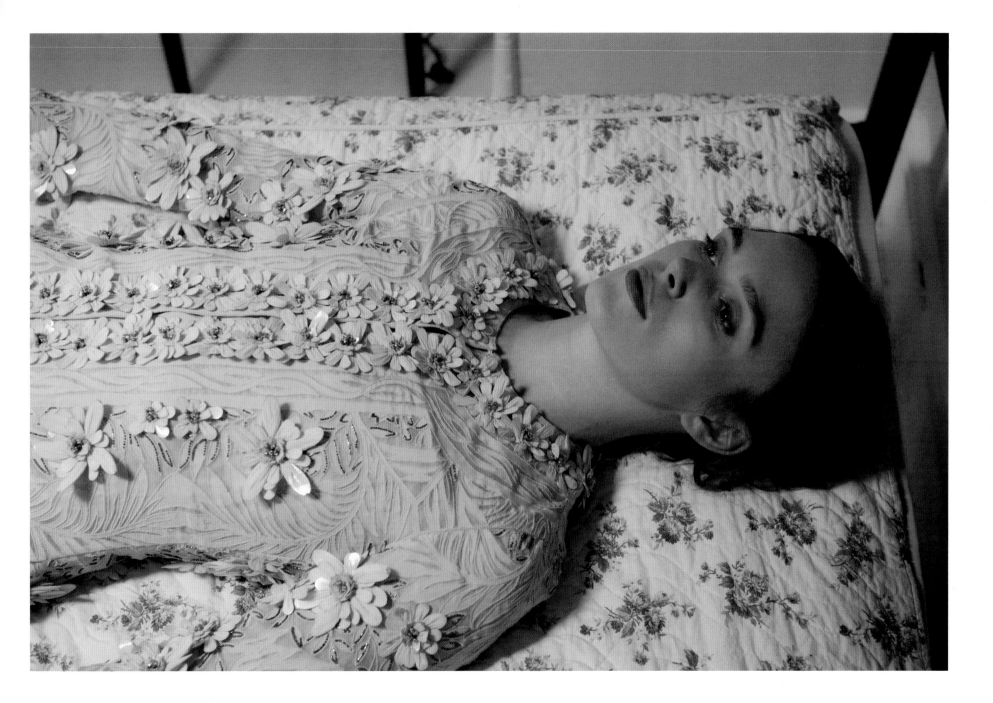

GIRLS ARE HEINOUS

FEATURING
OPHELIA LOVIBOND

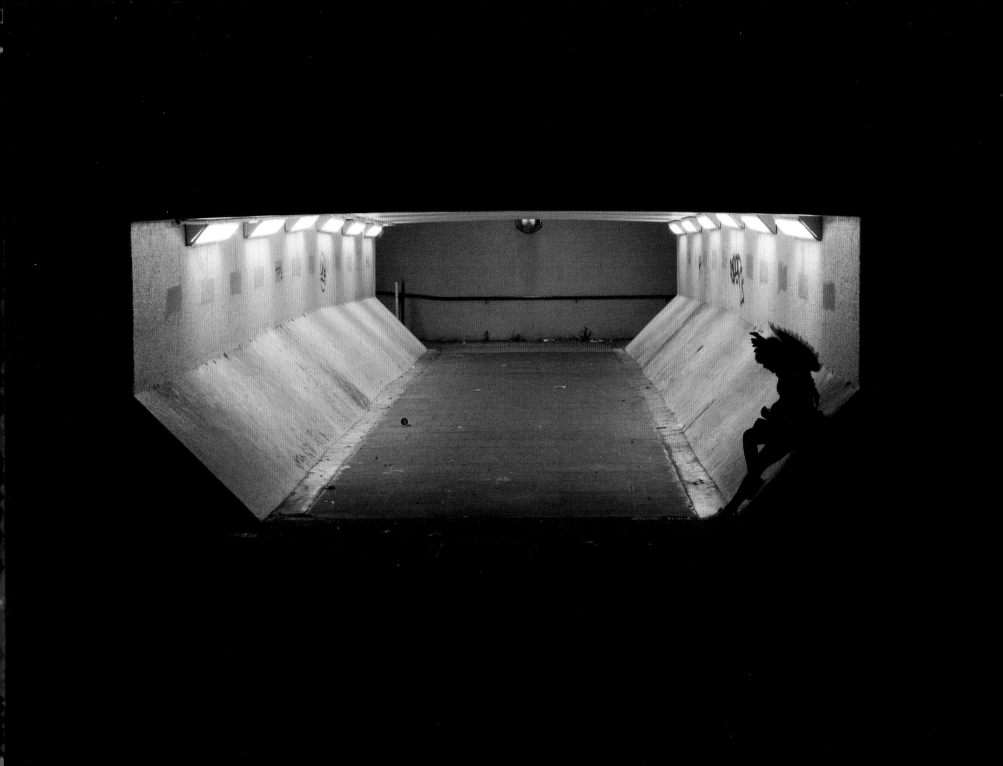

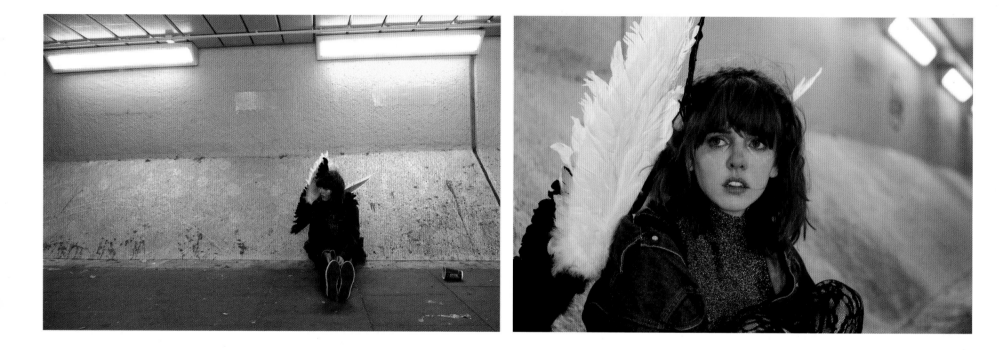

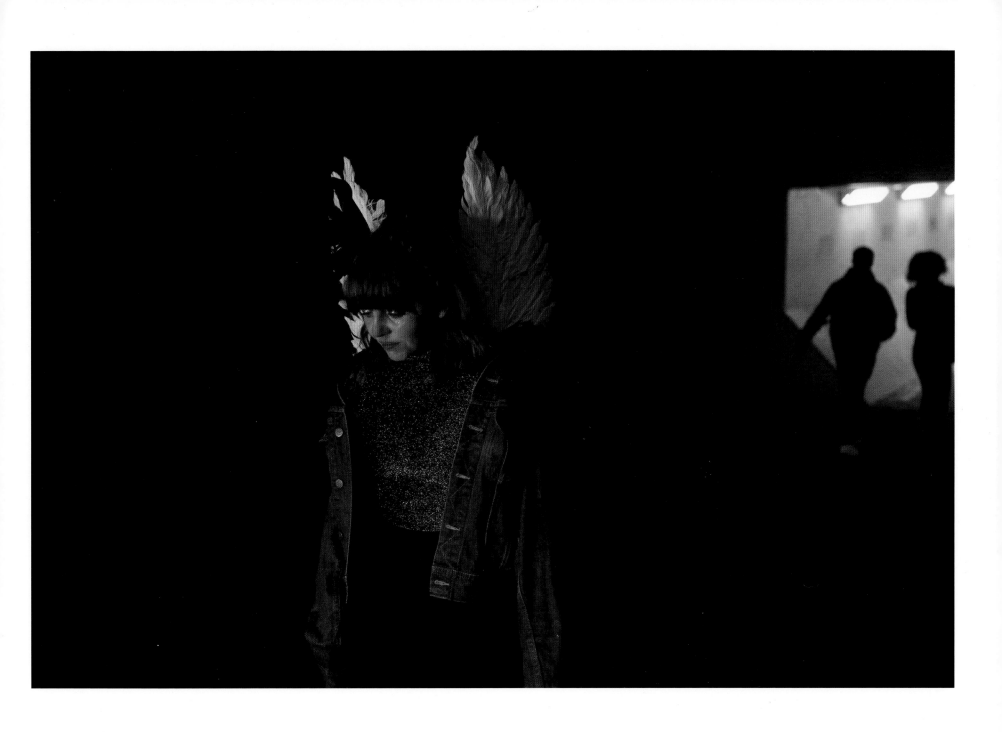

POINT OF NO RETURN
FEATURING SOFIA BOUTELLA

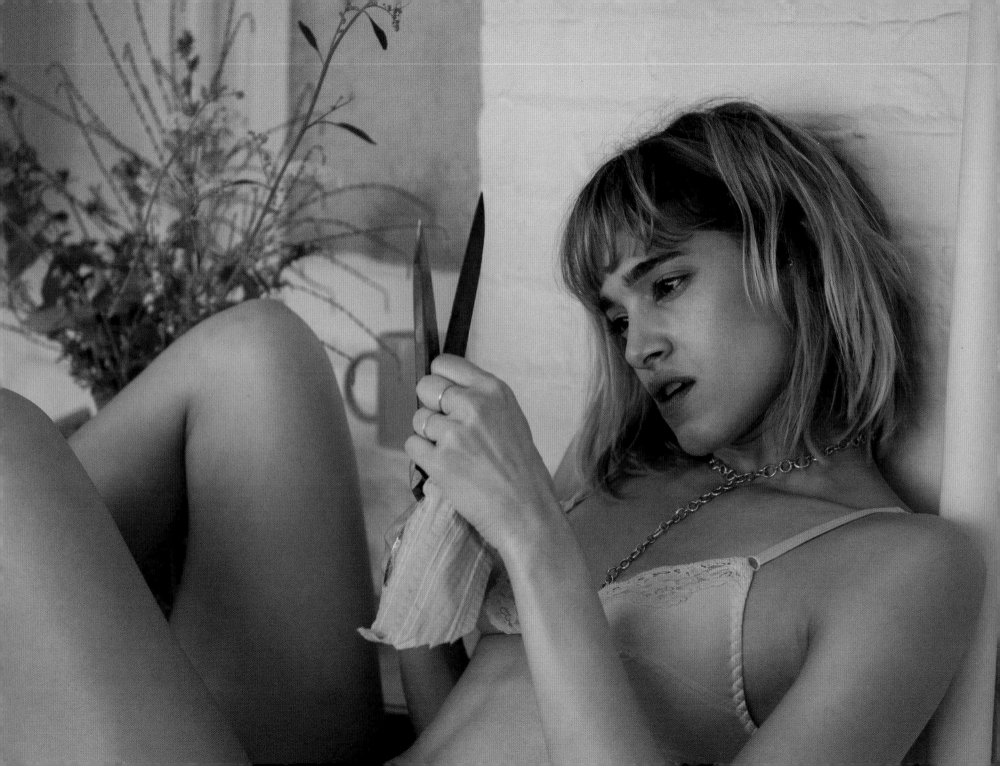

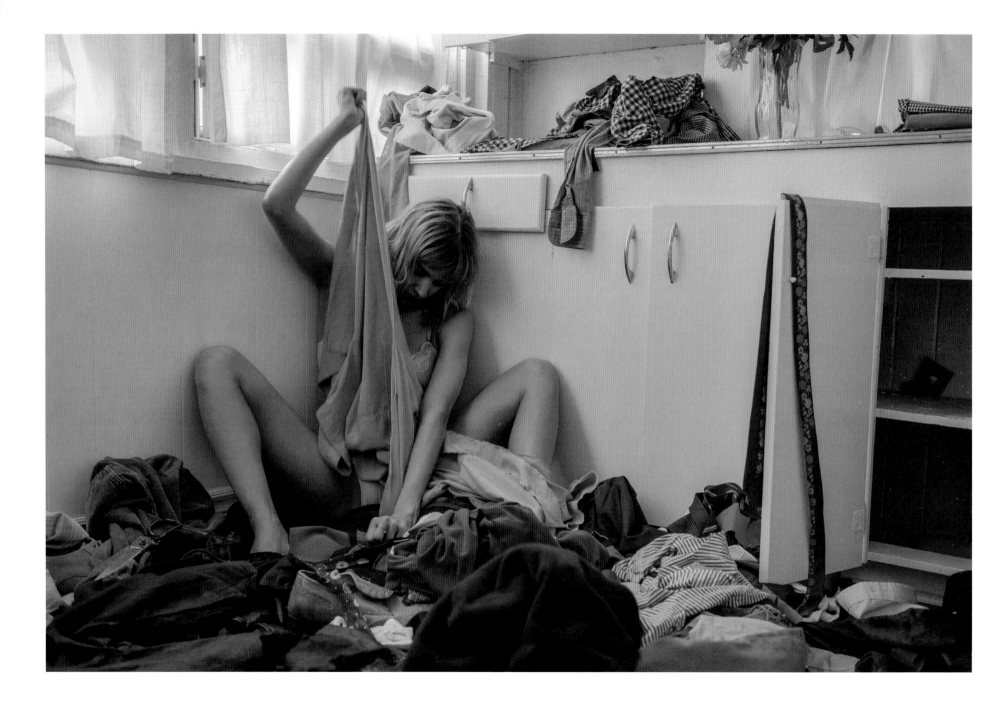

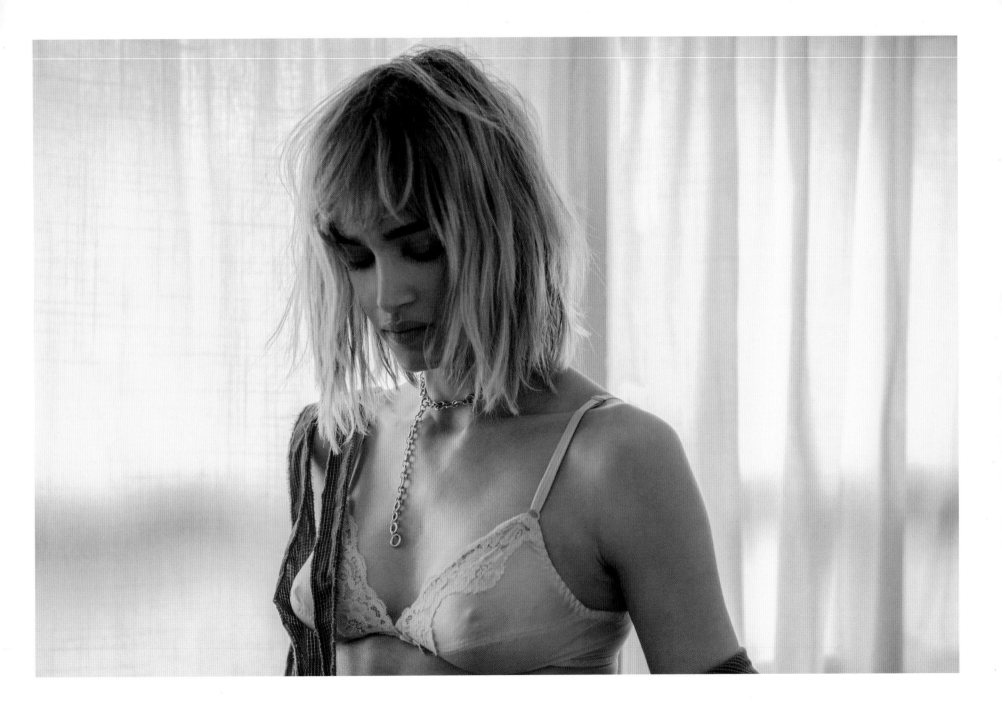

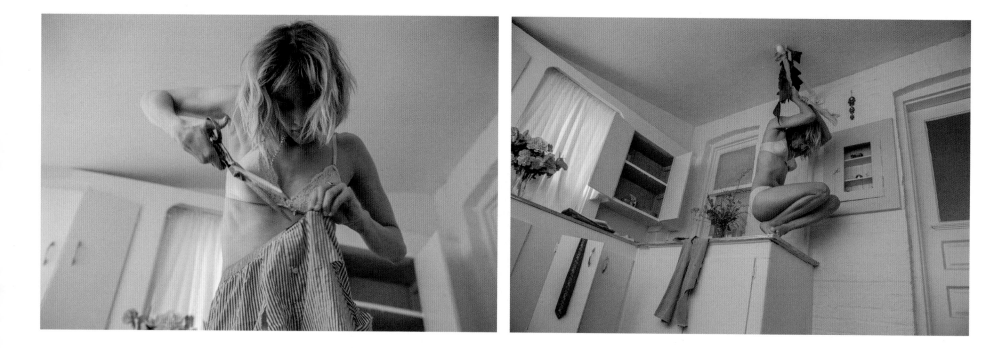

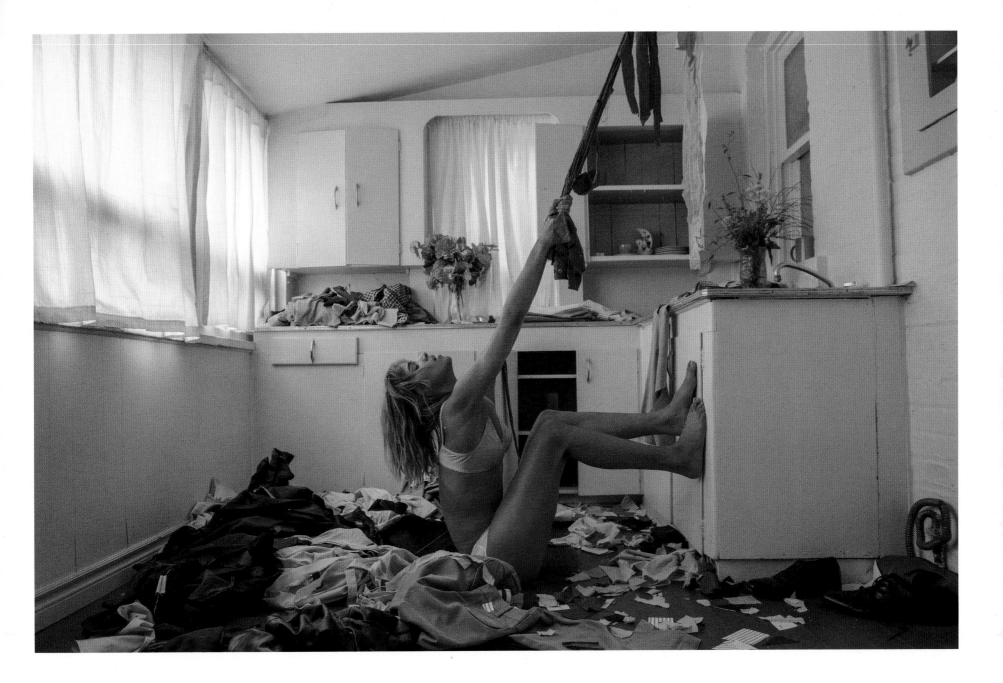

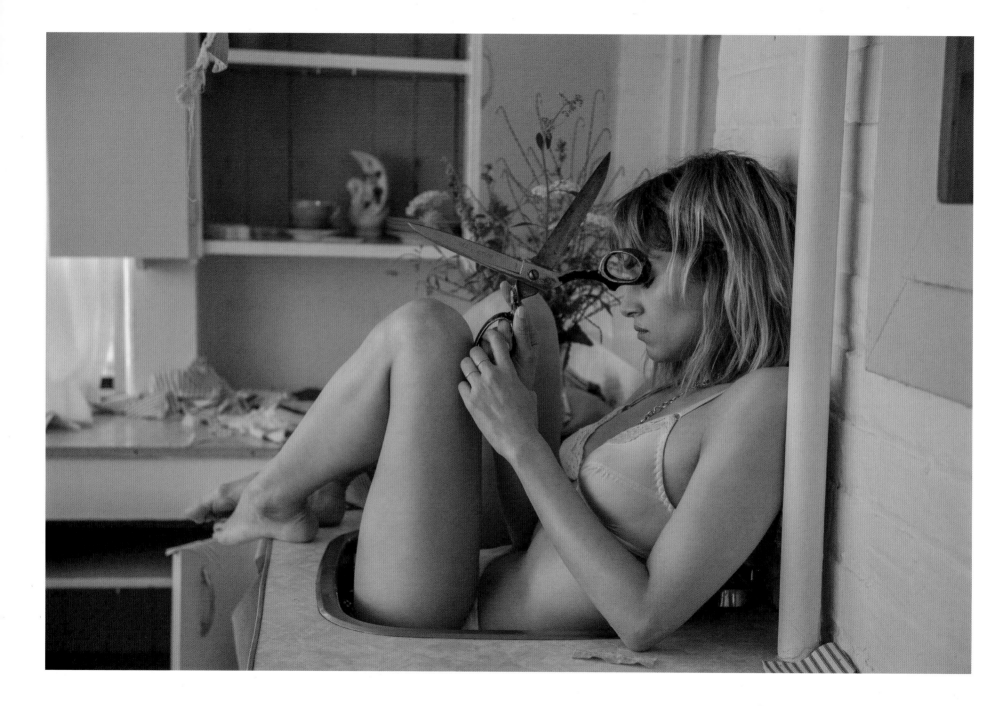

THE STORIES

11:11

The things she treasures above all else during a relationship are the very things that drive her mad once it has ended. Fire is the ultimate way to move on.

TO ALL THE MEN WHO LEFT ME HERE

Jilted by her former lovers, a woman insists upon living alone in a hotel room. She's been there a long time.

IN THIS HOUSE

Following a domestic altercation, a woman feels unsafe in her home, unsure of the outcome of her actions.

HE'S DUE HOME BY SUPPER

A woman sits outside of her house waiting for her first love to come home. Though he passed decades ago, she dresses up and waits for him.

THIS IS WHAT IT IS

A woman successful in all aspects of her life except for love has a moment of acceptance that that part of her life may never feel fulfilled.

HE SAID I WAS EMBARRASSING AT PARTIES

After being drawn in by an older man's allure and realizing he thought of her as only a child, a young woman hastily gathers her things and leaves her beau behind. She sets out into the night. As the sun begins to rise, she knows her only option is to swallow her pride and return to her childhood home, which she had previously rejected.

WHAT DAY IS IT? IT'S TODAY

A mother, alone in a big house. With her husband working late again, and the knowledge that their marriage is failing, she feels the importance of keeping life fun while being all-present to her kids, who are her greatest treasures and first priority. The title of this story is from their favorite bedtime book.

57 EAST 7TH

After learning that her husband is gay, a young woman sets out on her own, leaving her old life and her hometown behind. She moves into an apartment in Manhattan, the first place she has ever been able to truly be alone, and immediately finds contentment, both in her life and in herself.

IT WAS A YEAR OF MISTAKES

In the aftermath of a traumatic series of events, a woman sits in a half-burned wedding dress in the middle of the road.

PAST THE LILACS, IN THE CLEARING, MEET ME WHEN IT'S DARK

On the grounds of her parents' home, an isolated young woman mourns the loss of her childhood love on the anniversary of his death. Each year she revisits the special places they had together, and the secret monument she built for him in the woods.

WHAT KIND OF WOMAN

A woman who often feels like she is a possession to her overbearing husband is haunted by recurring dreams in which she is locked in a cabinet.

RECKONING

Wronged by her boyfriend, a spirited woman takes out her anger and frustration on his apartment—while taking some time to revel in the beauty of her destruction.

NOT EVERYONE LIES AS EASILY AS YOU

A photographer who finds out her boyfriend has taken a long-distance lover overseas decides to take a provocative self-portrait to send to the other woman.

BELOVED. NO. 31

An artist creates a performance-art installation to honor the woman she loves, but she is alone. Though her love is unrequited she continues to dedicate her art to her.

HE'S STAYING IN ASPEN

The wife of a wealthy businessman copes with his extended absences.

WHEN TEARS ARE IN YOUR EYES

Recalling the very beginning of her relationship, a woman reflects on her life with her husband as their marriage comes to an end. As she packs up her belongings to move out of the house they shared, she pores over the memories hidden in everything she owns and relives the emotions that went along with them.

TELL ME HER NAME

Somebody has been here. Something isn't where she left it. This story is about a wife who just found out about the mistress.

YOUR ACCENT, THE WAY YOU PLAY PIANO, YOUR MOTORCYCLE

She finds everything about him alluring. Even though she knew he'd break it, she gave him her heart. She stalks him—but he drove her to it.

A HEALTHY AMOUNT OF DELUSION

After seeing something on his phone, a woman feels completely differently about the man she thought she knew, as if a veil had been lifted on her entire life and relationship.

STAY HIGH

A young woman engages in reckless and self-destructive behavior in an attempt to numb the sadness she feels after losing the one she truly loved.

QUEEN OF SPADES, QUEEN OF SPADES

The Queen of Spades is a powerful card in the game of Hearts. She calls herself "Queen of Spades" as she cuts up a pig's heart, with a plan to deliver it to a very specific doorstep. The power to shock is the kind of power she likes.

I TOLD HIM NEVER TO CONTACT ME AGAIN

The campus library is the perfect setting for a clandestine rendezvous. Every day they set a spot to meet, and every day she worries he won't come. They both know it has been over since before it even started.

TELL ME TO GO

She isn't welcome here; she might be asked to leave anytime. She is careful not to forget her things, but not careful enough. This story is about the mistress.

I FEEL HIM

A woman alone in her home imagines that somebody else is there. And imagines what she would like them to do together.

BEGIN AGAIN

The end of her relationship is the chance to start her life anew, feel happiness again, be the person she couldn't be before, find herself. Her ending transforms into a beautiful future.

LONELINESS WAS A PLACE I DIDN'T WANT TO GO BACK TO

After the death of her great love, a woman ritualistically cleanses herself and her home in preparation for her own death.

GIRLS ARE HEINOUS

After pining for the boy of her dreams all summer long, a young art student arrives at a costume party anxious to see him again and make her move. She spots him across the crowded room but he is already wrapped up in the arms of another. Her friend. And she knew.

POINT OF NO RETURN

A young woman artfully and cathartically cuts up every piece of clothing in her former lover's wardrobe, and feels free.

CREDITS

PHOTOGRAPHY – Caitlin Cronenberg
PRODUCTION DESIGN – Jessica Ennis
DIRECTION – Caitlin Cronenberg &
 Jessica Ennis
PRODUCTION – Caitlin Cronenberg &
 Jessica Ennis

SARAH GADON

LIGHTING TECH – Tony Edgar
STYLIST – Dwayne Kennedy of
 THE COLLECTIONS
HAIR & MAKEUP – Andrea Brown
PHOTO ASSISTANT– Jeffrey Glaab

NOOMI RAPACE

STYLIST – Marissa Adele
HAIR & MAKEUP – Andrea Brown
PHOTO ASSISTANTS – Jeffrey Glaab &
 Quantel Wronski
PROP STYLIST – Caroline Pandeli
PROP ASSISTANT – Nadia Ismail

MENA SUVARI

STYLIST – Marissa Adele
HAIR & MAKEUP – Andrea Brown

GEMMA JONES

STYLIST – Karen Munnis
HAIR – Anna Chapman
MAKEUP – Celia Burton
PHOTO ASSISTANT – Kyle Meadows

JULIANNE MOORE

STYLIST – Marissa Adele
STYLIST ASSISTANT – Yafi Hoch
HAIR – Mandy Lyons
MAKEUP – Susan Reilly LeHane
PHOTO ASSISTANT – Andrea Brown
PRODUCER – Linda Hilfiker
CLOTHING – Christian Siriano

ELEANOR TOMLINSON

STYLIST – Karen Munnis
HAIR – Oscar Alexander Lundberg
MAKEUP – Celia Burton
PHOTO ASSISTANT – Kyle Meadows
CLOTHING – Self Portrait, Bionda Castana

AMANDA BRUGEL

STYLIST – Marissa Adele
HAIR & MAKEUP – Joanne Parks
PHOTO ASSISTANT – Paolo Cristante
STYLIST ASSISTANT – Aimee Lyons
CLOTHING – Line, Eliza Faulkner, Wilfred, Ecco

DANIELLE BROOKS

STYLIST – Marissa Adele
HAIR – Lacy Redway
MAKEUP – Jae Rich
PHOTO ASSISTANTS – Jeffrey Glaab, Travis Conn &
 Andrea Brown

IMOGEN POOTS

STYLIST – Marissa Adele
HAIR & MAKEUP – Alexander Tome
PHOTO & LIGHTING ASSISTANT – Marc Pilaro

BEL POWLEY

STYLIST – Karen Munnis
HAIR – Yoshi Miyazaki
MAKEUP – Celia Burton
PRODUCER – Kyle Meadows
CLOTHING – Petal and Grace, Rachel Freire

TESSA THOMPSON

STYLIST – Marissa Adele
HAIR – Matthew Monzon
MAKEUP – Gita Bass
PHOTO ASSISTANTS – Quantel Wronski & Travis Conn
CLOTHING – Tome
ACCESSORIES – Altuzarra

EMILY HAMPSHIRE

STYLIST – Marissa Adele
HAIR & MAKEUP – Andrea Brown
PHOTO ASSISTANTS – Jeffrey Glaab & Quantel
 Wronski
PROP STYLIST – Caroline Pandeli
PROP ASSISTANT – Nadia Ismail

SOOK-YIN LEE

HAIR & MAKEUP – Andrea Brown
PHOTO ASSISTANT – Quantel Wronski

ALISON PILL

LIGHTING TECH – Tony Edgar
HAIR & MAKEUP – Andrea Brown
PHOTO ASSISTANT – Jeffrey Glaab
PROP ASSISTANT – Alex Hurter

CHARLOTTE SULLIVAN

STYLIST – Marissa Adele
HAIR & MAKEUP – Andrea Brown

CHRISTINE HORNE

LIGHTING TECH – Bruce William Harper
STYLIST – Pascal Alhani
HAIR & MAKEUP – Andrea Brown
PHOTO ASSISTANT – Jeffrey Glaab
PROP ASSISTANT – David Watchorn
PRODUCTION ASSISTANT – Julia Marcello

GUGU MBATHA-RAW

STYLIST – Marissa Adele
HAIR & MAKEUP – Andrea Brown
PHOTO ASSISTANTS – Jeffrey Glaab & Quantel
 Wronski
STYLIST ASSISTANT – Aimee Lyons
CLOTHING – Kinross Cashmere, Valentina Kova,
 Angelys Balek, LINE, Esprit

NINA DOBREV

STYLIST – Ise White
HAIR – Jacob Schmidt
MAKEUP – Joanne Parks
SET DESIGN & PROP STYLIST – Veronika Ossi
PHOTO ASSISTANT – John Burke

MALIN AKERMAN

STYLIST – Marissa Adele
HAIR & MAKEUP – Andrea Brown
PHOTO ASSISTANT – Travis Conn & Jeffrey Glaab
STYLIST ASSISTANT – Rachel Triller
CLOTHING – Christian Siriano

JUNO TEMPLE

STYLIST – Marissa Adele
STYLIST ASSISTANT – Yafi Hoch
HAIR & MAKEUP – Andrea Brown

CARMEN EJOGO

STYLIST – Marissa Adele
HAIR – Lacy Redway
MAKEUP – Andrea Brown
PHOTO ASSISTANT – Travis Conn & Jeffrey Glaab
STYLIST ASSISTANTS – Ahzharae Gilchrist & Rachel
 Triller
CLOTHING – BreeLayne, Dolce & Gabbana (shoes)
JEWELRY – #203

PATRICIA CLARKSON

STYLIST – Ise White
HAIR & MAKEUP – Sheila McKenna
PHOTO ASSISTANTS – Quantel Wronski & Travis Conn

TATIANA MASLANY

STYLIST – Marissa Adele
HAIR & MAKEUP – Andrea Brown
PHOTO ASSISTANT – Quantel Wronski

PAZ DE LA HUERTA

LIGHTING TECH – Brian Gonzalez
STYLIST – Ise White
HAIR – Selda Cortes & Anthony Campbell
MAKEUP – Fumi Nakagawa
PROP ASSISTANT – Veronika Ossi

JENNIFER JASON LEIGH

STYLIST – Marissa Adele
HAIR & MAKEUP – Andrea Brown

KEIRA KNIGHTLEY

STYLIST – Marissa Adele
HAIR – Lacy Redway
MAKEUP – Daniel Martin
PHOTO ASSISTANT – Brian Gonzalez
STYLIST ASSISTANT – Giuliana Russo
PRODUCER – Linda Hilfiker
PRODUCTION ASSISTANT – Jake Murray
CLOTHING – Naeem Khan, Karen Walker

OPHELIA LOVIBOND

STYLIST – Karen Munnis
HAIR – Anna Chapman
MAKEUP – Celia Burton
PHOTO ASSISTANT – Kyle Meadows

SOFIA BOUTELLA

STYLIST – Marissa Adele
HAIR & MAKEUP – Jodi Urichuk
PHOTO ASSISTANT – Quantel Wronski
SET ASSISTANT – Jesse Lozier
PROP ASSISTANT – Basia Wyszynski
PROP INTERNS – N'Keyah Burton & Zainab Jeddi

RETOUCHING – Caitlin Cronenberg, Jeffrey Glaab, Mori Arany

ACKNOWLEDGMENTS

CAITLIN WOULD LIKE TO THANK:

The men in my life, whom I love madly, Geoff and Wolfy.

JESSICA WOULD LIKE TO THANK:

Nathaniel, the little man who always fills my bucket.

WE WOULD LIKE TO THANK:

Our incredible subjects, for giving so much of themselves to this special project and bringing our stories to life. Mary Harron, for writing our foreword. Our families, for their constant support. Our kids, Nathaniel and Wolfy, for generally being the best and making everyone smile. Alan and Linda Ennis, for their perpetual love, support, and encouragement. Bubbie Dina, for filling our mood boards (and hearts) with her unique style. Zadie Willy, for always asking about "the pictures." Jillian Ennis and Adam Angelowicz, for their wisdom. Jeremy Weisstub, for continued support and advice. The Cronenberg family, for proving that you can do what you love, and love what you do. And Geoff Grove for unwavering dedication and never-ending helpfulness, always.

Our amazing crew members, who lent us their talents, time and time again: Marissa Adele, Andrea Brown, Jeffrey Glaab, Quantel Wronski, Joanne Parks, Celia Burton, Karen Munnis, Sheila McKenna, Lacy Redway, Veronika Ossi, Jason North, and Alex Hurter.

Those who believed in this book before it was a book, and brought it to fruition: Pamela Silverstein, Andrea Barzvi, Jeffrey Henson Scales, and everyone at the *New York Times*, Caitlin Kirkpatrick, Sara Schneider, and the team at Chronicle Books.

Jessica Moss, for countless brilliant writing contributions, from the very first pitch to the very last story title. And Sabreena Peters for infinite editing help and lots of extra special magic.

Lola Rasminsky and Bob Presner for their artistic input.

Our friends who went above and beyond to help us get this to the finish line: Sarah Gadon, Teniel Humeston, Gabriella de la Torre, Aili McConnon, Nate Walton, Mike Brown, Joel Werner, Tommy Joiner, Karen Daniels, and Jacob Schmidt.

Those who were integral in the booking, wrangling, and securing of our talent: Bryna Rifkin, Robert Newman, Karen Long, and Megan Brophy.

Joel Behr, for keeping things good and legal.

Those who trusted us shooting in their spaces and those who let us invade their lives: Natalie Frenkel, Tommy Matejka, Abigail Van Den Broek, the Drake Hotel Toronto, the Meadows family, Steven Mayer, Elaine and Robert of Little Green, Dr. Gerardo Capo III, Sergei Smirnov, Darren Parker, Kyle Bernardo, Veronika Ossi, Natasha Koifman, Anthony Mantella, Natalie Brown, and Remo Tantalo.

Those who trusted us to shoot them with very little explanation: Stuart Mattila, Brian Gonzalez, Tim McAndrew, Alexander Tome, Isaac Strycker, Pete Raho, Greg Holden, Sara Basso, Jude Lewis, and Phoenix Lewis.

Those who provided extra support at shoots when we needed it most: Lydia Oliver, Hilary Stevens, and Maureen Brugel.

Natalie Frenkel, Rushka Bergman, Marek Milewicz, and Donna Cerutti, for being supportive before there was anything to support.

Everyone who has given us support in our day-to-day lives, making it possible for us to stay motivated and productive.

The artists who write the songs that make us feel powerful, the songs that make us cry, and the songs that make us feel brave.

And Carolyn Cronenberg, who, although she did not live to see the final book, was always its biggest cheerleader and number one fan.

A special thank you to our Kickstarter video crew:
VIDEO DIRECTOR – Brad Dworkin
VIDEO CINEMATOGRAPHER – Bruce William Harper
VIDEO B-CAM – Kevin Rasmussen

And our Kickstarter supporters, who helped get this project off the ground:

Alexandra d'Archangelo
Ali Jafri
Alison Jefferies
Andrea Grau
Andrew Marks
Angela Moralee
Ashley Poitevin
Bob Presner
Bruce John
Camille Shniffer
Carl Lyons
Catherine Tait
Cathy Drab
Chris Weitz
Christina Evans
Christine Kwan
Cindy Alvarez
Craig Burnatowski
Cynthia Yan
Dan Lyon
Daniel Cooper
Davina Pardo
Debbie Chewning
Desia Halpin-Brill
Gail McInnes
Greg Brill
Hilary Stevens

Ivy Ackerman
Jake Gold
Jamie Appleby
Jared Lorenz
Jennifer Mazin
Jenny Creed
Jill Cooley
Jillian Davina
Joanna Syrokomla
Joanna Wood
John Moran
Jordan Fogle
Josh Josephson
Julie McLaughlin
Julie Ng
Julie Sype
Katrina Saville
Kelvin Kong
Ken Nickerson
Laura MacCon
Lauren Carbis
Lola Rasminsky
Lorne Gertner
Martin Katz
Matteo Rossi
Michael Azeff
Michael Sparaga
Nadia Litz

Natalie Frenkel
Natasha Koifman
Nate Walton
Nicholas Mellamphy
Nicholas Packwood
Nick Wernham
Pamela Earle
Pauline Rapp
Peter Bregg
Peter Harvey
Rachel Silber
Rachel Yeager
Rhonda Barnhill
Richard Leiter
Rob Haney
Rodrigo Cabrera
Rudger Smits
Ruth Armijo-Carlson
Ryan Silver
Sausha Bodily
Scott Coulter
Sergio Navarretta
Stacey Yuen
Stephen Nichols
Terry Fuller
Todd Swanson